The Sunday Books

The publisher wishes to thank Sebastian Peake
for the patience and dedication he brought to this project,
as well as Fabian and Clare Peake, who allowed access
to their family's hidden treasure—
these drawings.
Thanks to Alison Eldred for her excellent scans.

This edition first published in hardcover
in Great Britain and the United States in 2011
by Duckworth Overlook, Peter Mayer Publishers, Inc.

LONDON:
Duckworth
90-93 Cowcross Street
London EC1M 6BF
www.ducknet.co.uk
info@duckworth-publishers.co.uk

NEW YORK:
Overlook
141 Wooster Street
New York, NY 10012
www.overlookpress.com
For bulk and special sales, please contact sales@overlookny.com

First published in France in 2010 by Éditions Denoël

A catalogue record for this book is available from the British Library
Cataloging-in-Publication Data is available from the
Library of Congress

Design by Marion Tigréat/Les Associés Réunis
Commissioning editor Jean-Luc Fromental

Manufactured in Italy
UK ISBN 978-0-71564-171-2
US ISBN 978-1-59020-711-6

Mervyn Peake's
The Sunday Books

With text by **Michael Moorcock**

Duckworth Overlook
London • New York

FABIA MPEAKE

SAR K· 19 4ᴱ

FAꞮ

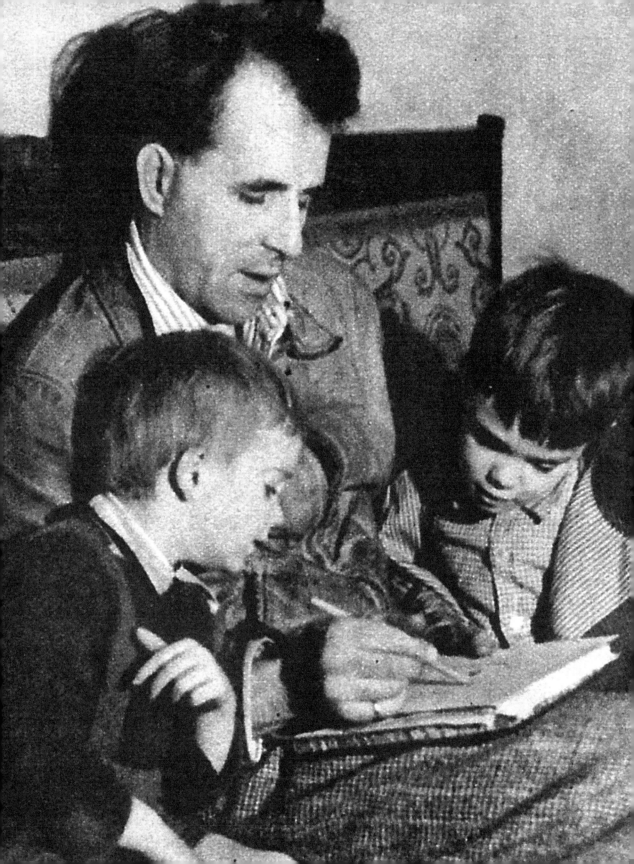

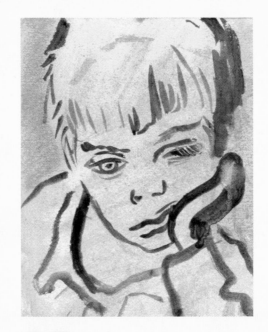

MERVYN PEAKE'S EARLIEST memories were a mixture of the exotic and the mundane, both of which could be discovered in Kuling, China, where he was born. This was a popular, cool mountain resort favoured by the good-hearted missionaries and doctors doing their best to relieve the miseries of desperate people who in many ways found themselves impoverished as a result of Western imperial ambitions.

This social, psychological and moral ambiguity would inform Peake's writings and paintings from the beginning, finding its apotheosis in the three superb and wholly original Titus Groan books, which remain unique in all literature.

These books are impossible to classify, standing outside
genre; idiosyncratic works of genius as original in English
literature as Swift, Sterne or Peacock; worthy, many critics
believe, to stand beside Lesage, Rabelais or Grimmelshausen.
Peake's stories reflect an unconscious understanding of
imperial injustice and inherited privilege, blending images
from oriental baroque, the English Gothic and Dickens, their
compelling narrative and grotesque but credible characters
guaranteeing Peake his place in the English literary canon. He
now regularly appears in the list of the UK's first fifty authors
when polls are taken to establish the English public's favourite
writers.

While sometimes described as 'fantasy' fiction, actually
Peake's stories are grotesque, sardonic and macabre but
have few magical elements and are *sui generis.* Apart from
his one novel set on Sark, *Mr Pye*, Peake rarely included the
supernatural in his work. Rather, he was influenced by his
favourite boyhood reading, including Dickens, Robert Louis
Stevenson, Edward Lear, Shakespeare and John Bunyan.
In common with other lads of his generation he also read
G.A. Henty, Morton Pike and S. Clarke Hook, whose work
appeared regularly in the periodical literature of his day and
was frequently illustrated by the great Stanley L. Wood. Wood
had spent years in the American West and had accumulated
an enormous amount of cowboy and Indian costumes and
paraphernalia, as well as clothing and equipment enabling
him to draw eighteenth-century pirates and highwaymen,

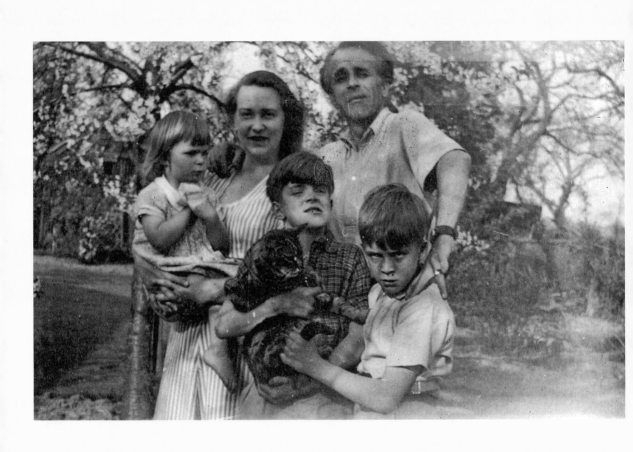

Indian army lancers, laskars or Chinese coolies. Peake's favourite boyhood artist, Wood illustrated both adult and juvenile magazines, including *The Strand, Pearson's Magazine, The Captain, Chums* and *The Boy's Own Paper.* Peake was not the only one to admire him. Wood's sense of movement, his understanding of anatomy and his ability to show all forms of action made him a favourite of many painters and illustrators of the day. In a radio talk given in the 1950s Peake recalled the deep impression made by Wood's illustrations for a serial called 'Under the Serpent's Fang'. It is fair to say that Wood's drawings and paintings were frequently more memorable than the stories they illustrated, and his portrait of the proto-Fu Manchu evil genius, Guy Boothby's infamous 'Dr Nikola' (from *Pearson's*), remains one of my own favourites. I have Wood's Nikola's portrait on my study wall to this day. From Wood in particular Peake learned to draw horses, which impressed his schoolmasters when he returned to England to be educated.

While at boarding school Peake's talents as an artist eventually encouraged his parents to send him to art school, first in Croydon and then in London. In an early self-portrait he painted himself as a pirate, and by the 1920s was dressing very much in the romantic, Byronic tradition of many of Wood's heroes. By the time he was training at the Royal Academy Schools, Peake had adopted a dashing appearance, with a broad-brimmed hat and, sometimes, a cloak. As a

student he also began writing fiction. Little of that early work survives, but some of it was published in an anthology of short pieces called *Peake's Progress* (1978).

In 1930 Peake even planned to write an opera, set in China with a hero who woos an emperor's daughter but is forced to become an outlaw, which owed a little to Gilbert and Sullivan. From the beginning his ambitions were as involved with narrative as they were with images and, together with the opera, he outlined a story to be called *The Three Principalities*, about a marooned sailor. The book was rejected by publisher Chapman and Hall and abandoned.

By the 1930s Mervyn had become a strikingly handsome figure with a wicked sense of humour, highly gregarious and full of fun. Many women remembered him from this period and not a few admitted to falling in love with him. Unusually, for his rather conservative era, he wore a gold earring. He had wonderful hands, one of which sported an enormous, almost vulgar, green malachite in a silver ring which emphasised his odd way of holding his pencil, a habit he retained all his life (together with his taste in rings!). At this stage he was still signing his work as Mervyn L. Peake, in echo of Stanley L. Wood, and he would go 'head-hunting' in London, drifting from cafés to pubs to the tops of buses, drawing mostly faces. He spent a great deal of time in Soho, London's main bohemian quarter. He joined a school of young artists grouped around a café known as Au Chat Noir and calling themselves

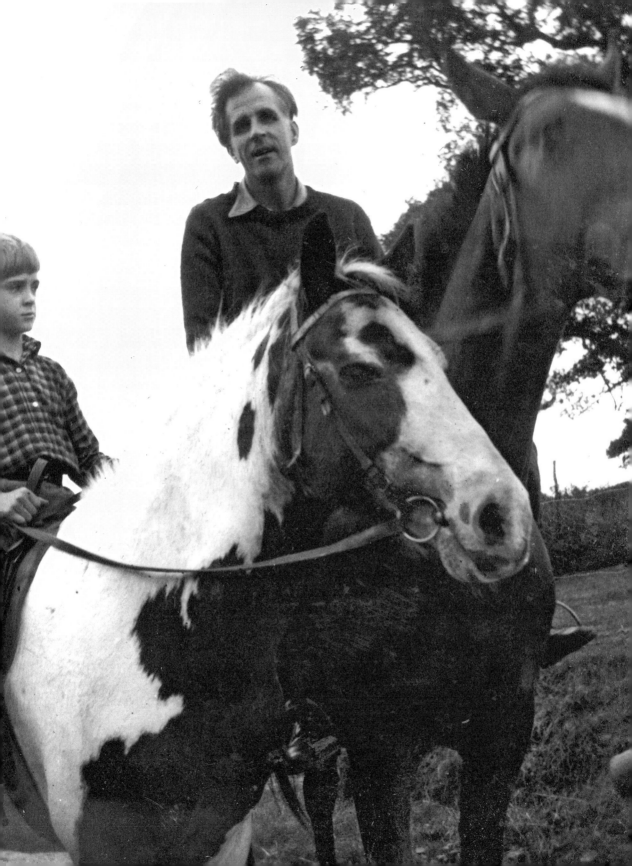

the Soho Group, later the Twenties Group, because they were all under thirty. He planned a book to be called *Head-Hunting in London*, based on pictures he began to have published in the journals of the day. He started to exhibit his paintings.

As Peake's reputation grew, a friend persuaded him to visit the Channel Island of Sark, where another acquaintance had permission from the local authorities to set up an artists' colony. In 1932 he got his first sight of the island. Sark is about twenty-five miles from Normandy and only about three-and-a-half miles long by one-and-a-half miles wide. Yet in that small space it has some wonderful scenery, superb cliffs overlooking deep bays, some fine beaches and, in those days, the further advantage of very cheap accommodation. Sark is a 'royal fiefdom', in many aspects an independent state, and in its day sheltered Victor Hugo, Algernon Charles Swinburne and William Turner as well as a host of less famous artists and writers.

Peake did not immediately settle in Sark. He had begun to do well in London. Among other commissions he designed the costumes for the Capeks' famous *The Insect Play*. Perhaps he didn't study hard enough as a result, because he failed his exams in 1933 and afterwards left for Sark, where Eric Drake was building a gallery that would exhibit their group's work. His paintings were generally considered the best of those shown, including landscapes and local portraits, and he, with the others, soon began to get publicity in the British national

press. At this time, too, Peake began to show a strong interest in circus subjects, perhaps after Chapman's Circus had visited the nearby island of Guernsey. By 1935, however, he had left Sark. He claimed that the local ruler, the famous Dame of Sark, had ordered him to leave after he had been discovered drawing the corpse of an old man who had been laid out in the chapel.

Back in England, Peake first lived with his parents in Surrey, sharing a studio with a friend. He returned to his old haunts like Au Chat Noir and began work on a children's story which would become his first published book, *Captain Slaughterboard Drops Anchor*, bearing some similarities with other work of the 1940s such as his illustrated book of children's nonsense verse *Rhymes Without Reason* and *Letters from a Lost Uncle*, as well as his far more ambitious *Titus Groan*. He was still unable to make a living from his painting and began to teach life drawing at the Westminster School of Art. He mixed with a group of poets which included Roy Campbell and Dylan Thomas. Thomas chose to consider Mervyn (whose dark looks were extremely Celtic) as a fellow Welshman and they became friends, though temperamentally had little in common. Thomas talked about doing a travel book together but tended to forget appointments and as often as not turned up unannounced in Mervyn's studio, throwing up on his couch and borrowing his clothes.

Both Thomas's and Peake's fame continued to grow.

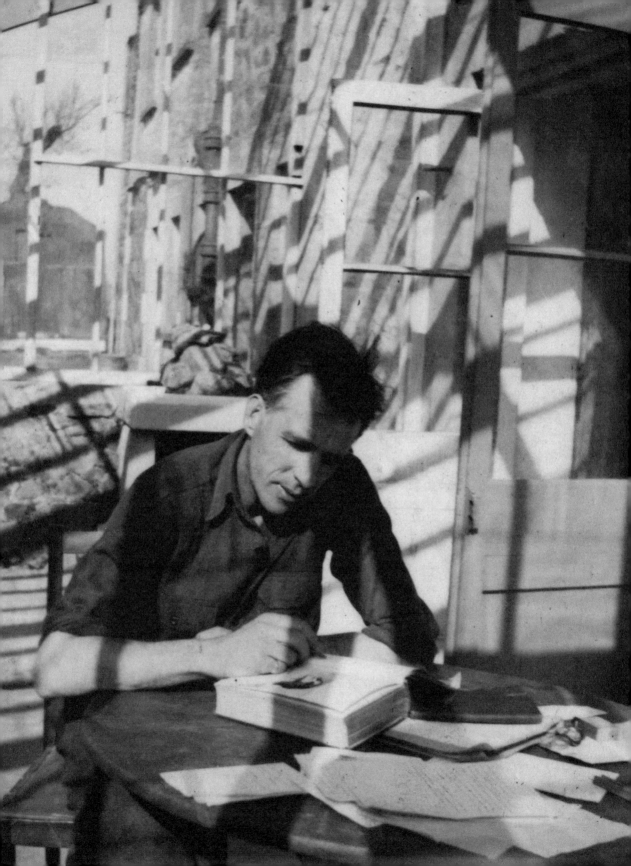

While teaching at Westminster Peake met Maeve Gilmore, a fellow South Londoner, who was exquisitely beautiful and extraordinarily shy. She was studying sculpture. They fell in love. They made a remarkable couple. Although often tongue-tied and self-conscious, she struck all who knew her as having, in the words of one friend, 'a Madonna-like composure'. She also had a powerful and surprisingly down-to-earth sense of humour, which was one of the things I most enjoyed about her when we met years later. Peake certainly appreciated it. Her beauty and grace, as well as her humour, inspired him. He began to write some of his best poetry and became regularly published. 'I am too rich already,' he wrote, 'for my eyes mint gold.' The daughter of an Irish surgeon, a rather strict Catholic, she was not at all sure what her family would think of the son of 'low church' general practitioners, and indeed their romance was not to get much of a Gilmore blessing. Eventually, however, they married in December 1937 at St James's, Spanish Place, a fashionable London church.

In 1939, when *Captain Slaughterboard* was published, Peake's fortunes were improving. He was becoming well-known and increasingly sought-after. But by January 1940, when his first son, Sebastian, was born, the Second World War had begun to colour his future and he had to make plans about how best to serve his country. At one point he returned

home in the Blitz to find Sebastian missing and eventually discovered him sitting on Dylan Thomas's knee, enjoying the 'fireworks' with the poet.

While he waited to be commissioned as a war artist, Peake worked on *Titus Groan*, the first of his great trilogy, a tale of stultifying privilege and injustice, full of grotesque but highly credible characters and wonderful, original language. He began to compile his first book of poetry which would be *Shapes and Sounds, 1941.* That same month his illustrated *The Hunting of the Snark* appeared and was very well received. Thomas introduced him to the influential Kaye Webb, editor of *Lilliput* magazine, which published a vast amount of both British and émigré talent and had been founded by a Hungarian, Stephan Lorentz, recently escaped from Hitler's prisons. Kaye Webb not only commissioned illustrations from Peake, she also published his writing, even after he was recruited into the army. Through these harrowing years he completed *Titus Groan*, which was published in 1946 after he had been sent to Belsen as the first war artist in the camps. The experience was to have an enormous influence on future work. By the end of the war, Peake's reputation was high, as a poet, novelist, illustrator and painter. The joke was frequently made that it was just as well he didn't play the violin as well.

By the end of the war, with money coming in, he and Maeve felt they could afford to 'retreat' from ravaged austerity

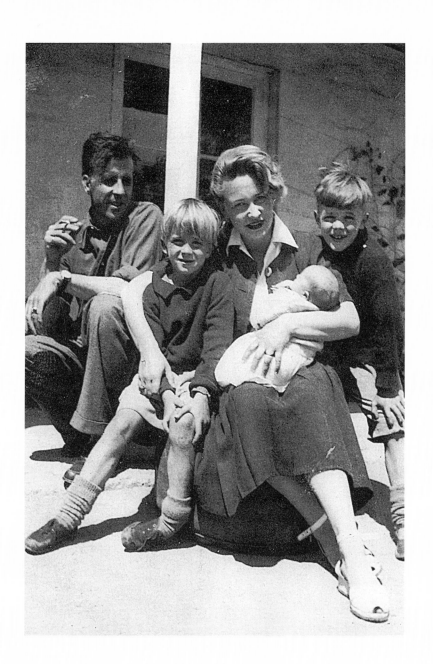

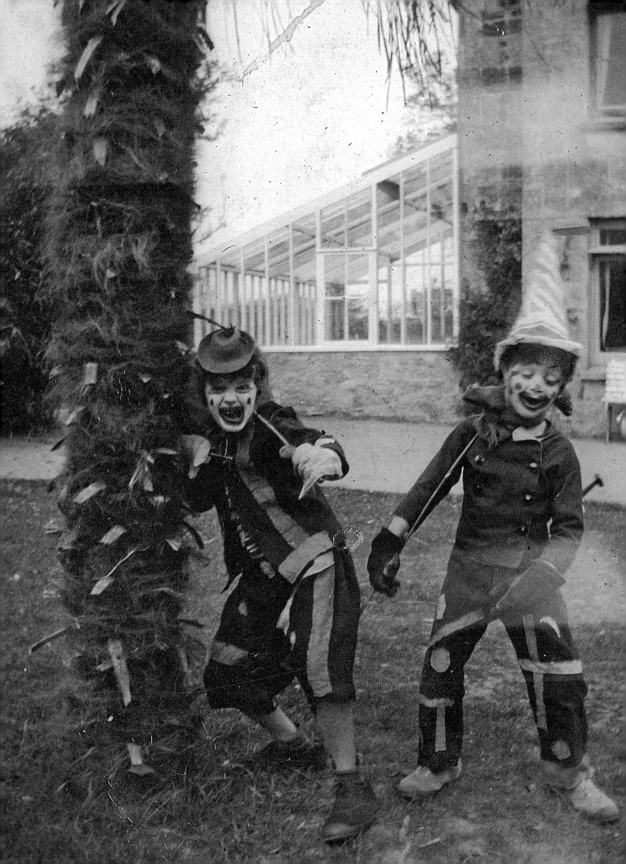

London and Peake suggested they look again at Sark, which she had visited briefly with him. Renting a large, rather primitive house on Sark, Peake began *Gormenghast* and completed his *The Rhyme of the Flying Bomb*, which was to be lost and not published until 1962. In homage to his beloved R.L. Stevenson, he illustrated *Dr Jekyll and Mr Hyde* and *Treasure Island* as well as *The Swiss Family Robinson* and others. He also wrote a children's book, *Letters from a Lost Uncle*.

In lots of ways the Sark years were the Peake family's happiest. Peake was something of an ideal father. He knew how to entertain his boys with conjuring tricks, bizarre games and practical jokes. Although, like all artists, he had anxiety spells and claimed to be desperately in need of peace and quiet, he loved to be part of his family and, rather than be hampered by their presence, was actually inspired by them. The boys went to the local school and in 1949 a little girl, Clare, was born. By now their pets included a cat, some ducks and a donkey who more or less had the run of the household and frequently turned up in illustrations (including some you'll see here). Every so often Peake would return to London to make some well-received radio broadcasts, to obtain further commissions and to discuss ideas for books. He published a superb book on technique, *The Craft of the Lead Pencil*.

When he was away he was homesick, and when he was home he quickly resumed his habit of drawing for his boys

every Sunday. This was a delightful time for them and for Peake. They had little cinema and no television and precious little else to do on Sark, especially on Sundays, especially in the winter, with the wind howling outside a house with no mains electricity. The boys would sit on the arms of his chair, watching as he called on his own boyhood memories and enthusiasms (reflecting perhaps on his own unpublished boyhood tale *The White Chief of the Unzimbooboo Kaffirs*, 1921) to draw pirates, cowboys, weird monsters and weirder characters of the sort who would later appear in his own nonsense books like *Rhymes Without Reason* and *A Book of Nonsense.* Clowns, trains, forest outlaws, jungle animals were produced out of the whole cloth of his imagination, frequently at the immediate demands of his sons, who might want him to draw a plane, a ship, a lion . . . The drawings contained private jokes (as in some of his published work) and homages to his own heroes. Until the boys were ready to go to school (and the Peakes were beginning to find it impractical to remain on Sark) he filled page after page with drawings. An astonishing number of them were in full colour. Though Stanley L. Wood's style had never influenced him, the earlier artist's subject matter had. Peake's own childhood revisited, he offered his children private versions of *Chums* and *The Boy's Own Paper.* Only because Peake drew them is the phenomenon especially remarkable, of course. Many less talented parents do the same for their children. But Peake

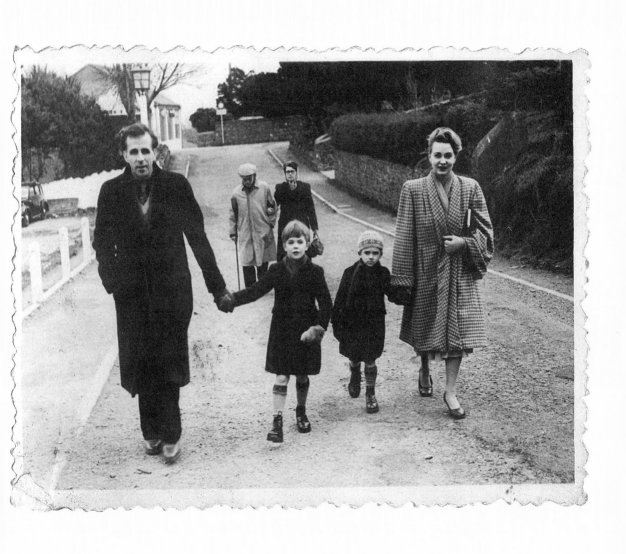

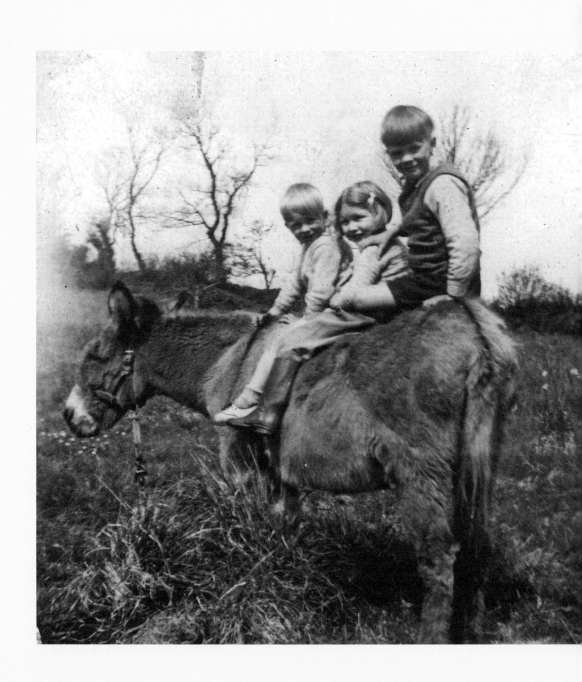

was a very special talent, and he was an artistic powerhouse. The work produced for his children in the 1940s is quite as vivid today. Sadly, any stories and rhymes which Peake invented to go with the drawings were never written down, though some similar ideas might turn up in later books, including the Titus books.

Circumstances brought the family back to the mainland by 1949. For Peake the following decade was to be one of growing ill health and ill fortune. *Mr Pye*, a fable set on Sark, won the prestigious Hawthornden Prize in 1953, but his plays, many of them idiosyncratic and surrealistic, rarely ran for long and failed to make him the money he needed. In spite of continuing to accept commissions to illustrate many classics, Peake found his painting, poetry and fiction going briefly out of fashion at exactly the time he began to experience the early symptoms of what would eventually be diagnosed as Parkinson's Disease.

By 1957, after completing the first draft of the third Titus book, *Titus Alone*, which drew considerably on his own experience, including the war and Belsen, he started to feel the typical tremors and loss of attention which were to worsen. He received radical and, by modern standards, rather brutal treatment in a desperate effort to help him, but this did nothing to improve his condition, even as a new generation began to discover and celebrate him. He continued to work until only a few years before his death in 1968 as

his reputation grew rapidly. Today he is regarded as one of the twentieth century's greatest imaginative artists, showing regular exhibitions around the world, while his fiction and poetry are consistently reprinted. His work has been adapted to film, TV and radio, even opera, and his *Rhyme of the Flying Bomb* was set very successfully to music by Langdon Jones, yet he was never to become conscious of his own remarkable success. He died in 1968 in a small Oxfordshire nursing home run by Maeve's brother.

Almost as soon as he died his reputation began to grow still more rapidly, and now everything he produced in his lifetime has been reprinted many times over, apart from the 'Sunday books' done for his boys. It has been my ambition for some years to put at least some of these drawings before the public and give perhaps a taste of the narratives and verses with which he might have embellished them. There are still many more to be published.

As you look at this work, it is worth bearing in mind an extraordinary fact. No matter how impulsive his public work was, Peake did not generally produce drawings for people 'on the spot'. Although he was a generous-spirited artist and writer who gave much of his work away, he was very rarely able spontaneously to draw on request. Yet every weekend, for several years, he produced these drawings for his own children. Therefore I think we are perhaps doubly privileged at last to enjoy the pleasure that Sebastian and Fabian experienced more

than half a century ago on Sark. We must be thankful this work has survived. Later, Maeve Peake would paint wonderful murals for the benefit of her own grandchildren. She covered entire rooms of their house in Drayton Gardens, London. Hardly an inch of wall space was not filled with her work or Peake's paintings. Sadly, when the house was sold on Maeve's death, the new owners whitewashed them all. We are lucky, therefore, to have so many illustrations to remind us of those remarkable parents. Few of us, loving mothers and fathers though we may be, have such a wealth of talent and are able to entertain our children so thoroughly. Now at least some those drawings can be reproduced for the benefit of those outside the privileged Peake family circle which today, of course, also consists of Sebastian's, Fabian's and Clare's children and grandchildren.

Mervyn Peake's last years were filled with despair and misery through which his friends and family vainly sought to save his health and his reputation. We lived in frustrating times, when so much less was known about conditions of the brain, and we could not make his health any better. We had to watch that great, creative intelligence slowly slip away from us while his reputation continued to grow around the world with every passing year. Yet Peake's humour remained with him almost to the end and continued to inspire us. Until quite late in the progress of his illness he was able to make a joke and produce a small, humorous sketch. I think

the illustrations in this book will serve to show that other,
even more personal side, of a great artist at home, and I can
only hope that Mervyn Peake, who became such an inspiring,
wonderful friend to me and my own family, would forgive
any liberties I have taken here to supply his pictures with this
narrative.

Michael Moorcock, Paris, September 2009

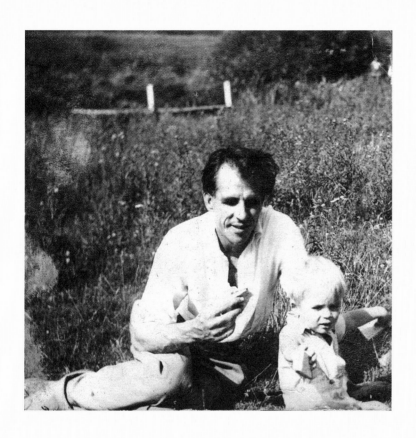

Mervyn Peake'
The Sunday Book
With text by
Michael Moorco

1946-2011
Duckworth
Overlook

Contents

1. Captain Crackers'
Shanty
2. The Shipwrecked Circus:
or,
The Desert Island
Redskins
3. The Nightmare
Races

CAPTAIN CRACKERS' SHANTY

(Sung to the tune of a very old squeezebox)

I'm back from the oceans, says Captain C,
With a tale or two, I'm tellin' thee:
I've stories of ships and islands and beasts,
Of weeks of hunger and fortnights of feast
From the coldest north to the hottest East!
Are you ready to hear 'em? asks Captain C.

Right, settle down lads and I'll get out my pen,
You tell me your favourites and I'll draw 'em again
I'll draw you the pirates, the cowboys, too,
And I'll add in some Indians, maybe a few,
I'll draw what you like, if you give me a clue,
Let's find us some paper—and now here's my pen.

So what do you want to know, lads?
What would you like to see?
Shall I start out my story by talking about me?

Well, I was born some years ago, boys
In a little town in Kent
At the south-east end of London
Where strangers never went.

A small, provincial town, boys,
As normal as can be
And sometimes they'd call me 'crackers'
And I'd reply, 'Mais Oui!'

At a very early age, lads,
I determined what I'd be,
I'd become a cruise-ship captain
And take land-lubbers to sea,
I'd bring folk aboard a liner, boys,
To show 'em wild, exotic sights
So they'd know what they were missing
By making airline flights.

Well, I soon got down to Dover,
But ships were few and far between
I'd expected to see hundreds
But only ferries filled the scene
They were big and bland and dull, boys,
And disappointed me—
Apart from one old schooner,
Whose masts I counted: Three!

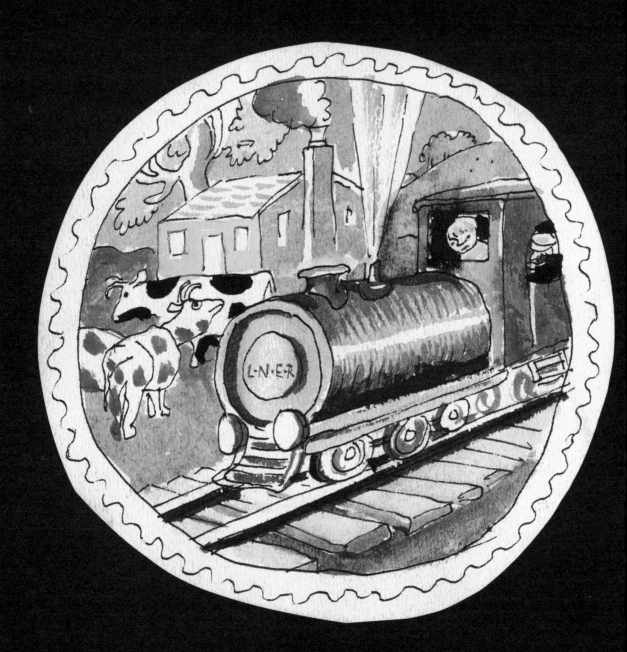

(**T**hough muffled in a jersey and a cap
and bearing a surprising likeness to their dad,
Captain Crackers addresses Sebastian and
Fabian):

I had a pretty normal boyhood, all in all,
though memory blurs a few details . . .

. . . the usual pursuits, including visits by bus
to the zoo and the circus . . .

But as soon as I could, I headed for the
coast . . .

● ● ● **A**nd that's where I met Billy Belly and his pedigree tripehound 'Tracy', who was very good at sniffing out fresh tripe and had been named for the famous American detective.

Billy promised me a start in the pirate life. Though he explained the joining fee would take up most of the pocket money I'd saved . . .

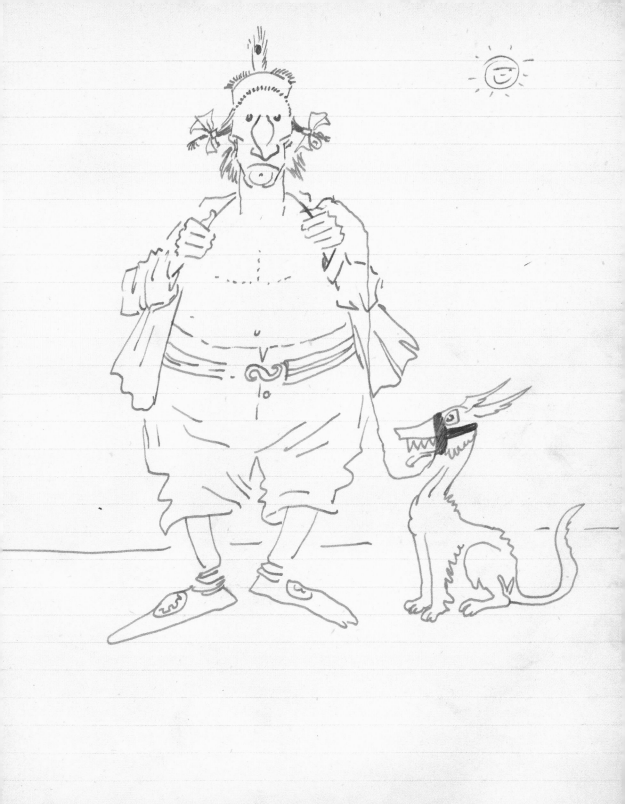

It's mighty hard to be a proper pirate these
days, what with steam and long-range guns
and so on, and frankly people don't have the
imagination for it. You're forced to seek out
distant waters and impossible ports of call. If
I hadn't been lucky at discovering such places,
I doubt if I would have had a career at all . . .

But I *am* lucky, see . . .
And pirates love a lucky skipper.
It cheers 'em up and keeps 'em chipper.

My first job, on *The Old Porcupine*, didn't
go very well, however. After a brief
apprenticeship as Assistant Sea Cook I got the
sack.

This sounds bad, perhaps, but actually all
they did was maroon me. The sack they gave
me contained some soft-tack, some rum and a
rather nice monkey for company.

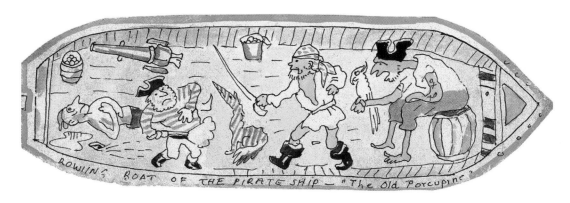

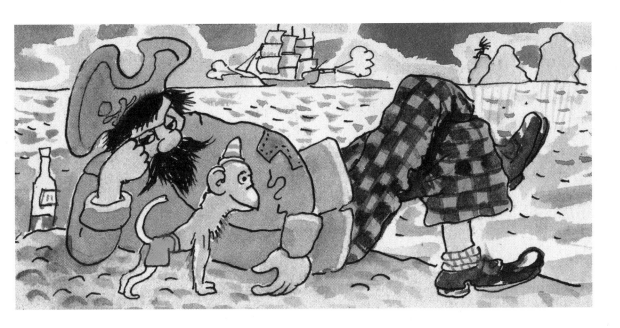

Feeling I hadn't impressed my fellow corsairs
as being mature enough, I grew a beard.
The beard itched and partly because of this I
sulked for quite a few weeks . . .

. . . **U**ntil the fateful day when *The Golden
Farthing* was wrecked on my island—
providing me with a ready-made crew . . .
. . . but sadly not much in the way of a ship.

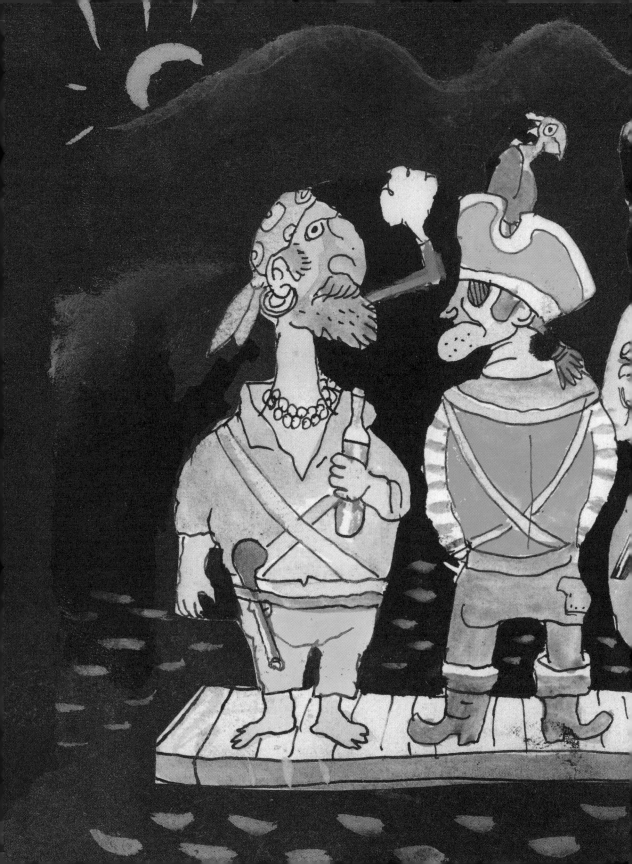

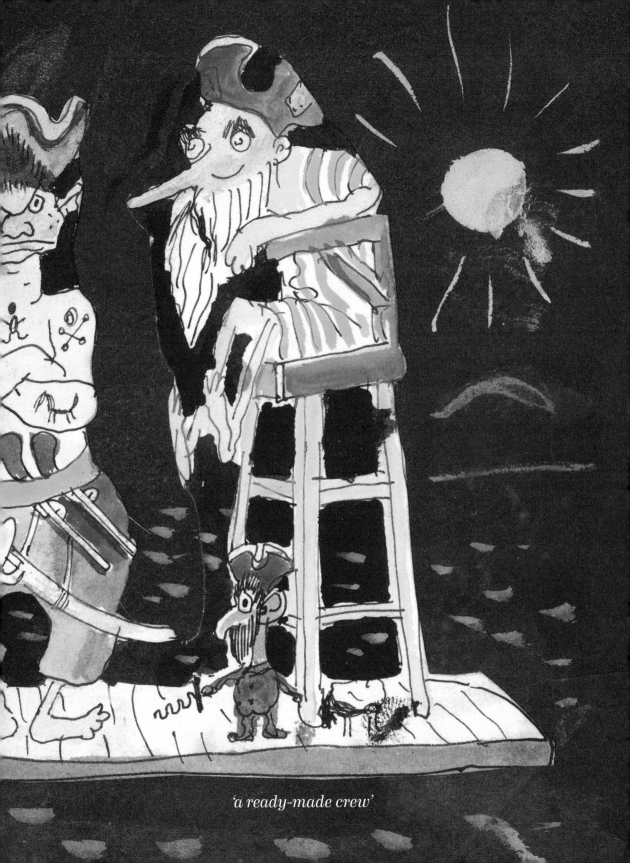

'a ready-made crew'

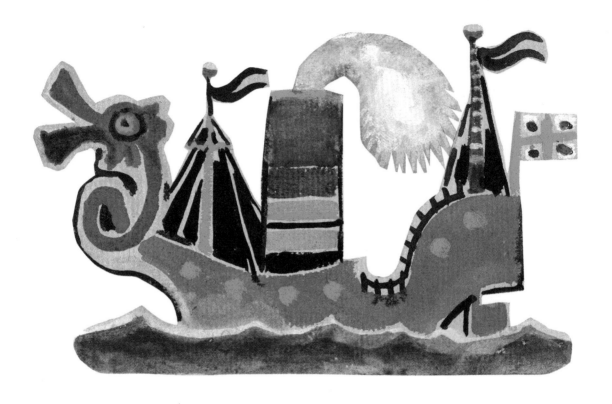

As it happened, one of the last of the old-fashioned pirate sailing vessels dropped by my island. Most of the crew had deserted and the remainder were desperate men. They had found no response to their advertisement in *The Corsair Gazette*, asking for someone to fill the position of captain.

A lot of the pirate stories in books or on the screen are about quarrels amongst a great many different candidates trying to get the captain's job.

That is mere fiction.

Most pirates are a feckless lot. Not one of them wants to take the responsibility of running a ship . . . (this also accounts for the poor profitability of piracy, these days, and why so many people choose banking instead). Therefore, to my surprise and glee, the job was mine if I wanted it to be.

Sure enough, I soon discovered that, even after a lick of paint and a new name, *The Black Leopard* wasn't a going financial concern and was facing bankruptcy.

The rules of the Pirate Brotherhood were somewhat out of date and restricted what we could do.

We could not, for instance, take tourists around the Spanish Main (unless we made them walk the plank) and neither could we sell franchises or start a fashion house.

Piracy of the old-fashioned sort mainly declined for this reason.

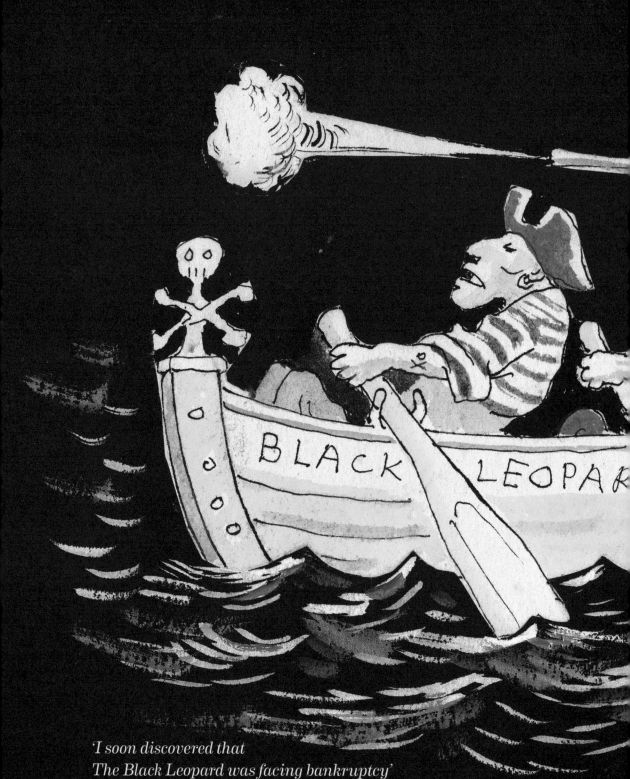

'I soon discovered that
The Black Leopard was facing bankruptcy'

The basic problem, of course, was the fault
of people like James Watt, Robert Stevenson
(the one who built the first rocket, not the one
who wrote that rather romantic version of the
pirate life *Treasure Island*), Robert Fulton and
Isambard Kingdom Brunel, who helped create
the modern steamship.

Not only were these steamships faster and
better armed, they required an entirely
different sort of executive officer to run them,
from stem to stern and from top-mast (or
funnel) to keel.

The kind of people who managed such ships
had a very limited sense of romance and
their favourite charts were cash-flow charts.
Even Joseph Conrad, who wrote a lot about
steamships and was personally pretty attached
to them, felt this to be true.

In the main, romantic emotions tend to be
engendered by images and ideas no longer
of much use or much danger to people—
ruined castles, antique weapons, mediaeval
outlaws, 18th-century highwaymen, Regency
dandies, Western road agents and, of course,
traditional pirates. Modern pirates, generally
people who capture yachts and oil-tankers
or steal the work of musicians and writers,
are not viewed with anything like the same
favour.

'ruined castles, antique weapons, mediaeval outlaws...'

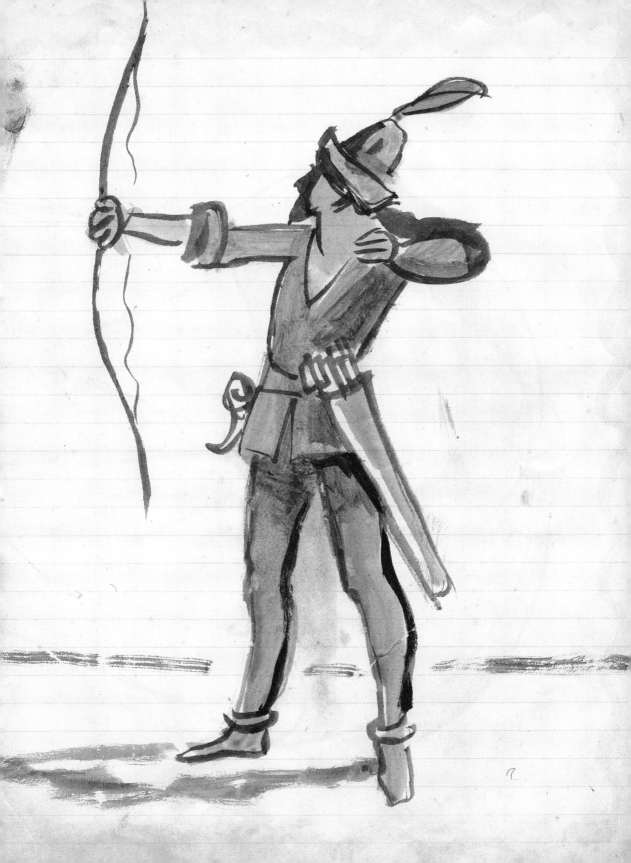

So modern 'pirate management executives' were not attracted to any of the stuff usually associated with the buccaneering lifestyle, such as colourful costumes, interesting tattoos, scarifications, missing organs or limbs, smoking clay pipes, keeping parrots (or sometimes monkeys), skull-and-crossbones flags, fancy old (but inefficient) weapons, walking the plank, being hanged at Execution Dock and, perhaps most to the point, keeping their wealth in big wooden brass-bound trunks. This new breed believe in putting their profits into banks, property, building societies, stocks and shares, investment portfolios and so on. They know that if anything goes wrong governments won't hang them but will actually bail them out.

It's really no wonder that they actively disapproved of burying trunks in holes roughly indicated on crudely drawn maps which were routinely stolen or lost.

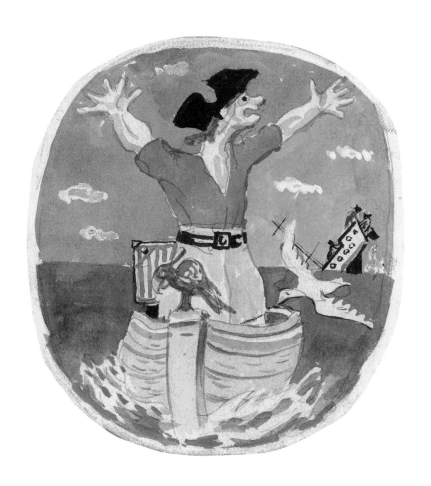

At first I thought an inexpensive change
of image might be all we needed.
Thus I gathered the men together and told
them that under my command the ship
would again be rebranded as *The Black
Shark*, a decidedly appropriate name for a
rapacious sea-going vessel. Altogether
more blood-curdling and sinister, I
felt.

This change of brand name, however, proved a
further failure.

By the following spring we hadn't outrun
or boarded a single likely merchant ship.
We were tired of living on fish and chips.
Especially since the chips were wooden ones
sliced off our masts, which were getting a bit
thin as a result.

The next time our lookout sighted an island, I
again lined our men up and addressed them:

'Lads,' said I, 'We're in a bit of a pickle!

'. . . indeed, it would be a little happier for
us if we *were* in a pickle!

'. . . or at least a pickle barrel, since we'd
have a differently flavoured wood to eat for a
change!

'. . . what I mean, of course, is that we
have a serious treasure-flow problem. We
have a fairly seaworthy ship, plenty of canvas,
a good supply of cannonballs, a lot of rope,
cutlasses, Navy pistols, etc.' (I won't list the
entire inventory I gave them because you
probably have better things to do with your
time than they had.)

'But we are noticeably short on, viz:

Full holds,

Salt pork,

Apples, lemons,

Grog,

'And all the usual wholesome victuals an ordinary, hard-working pirate might expect to find on his ship, and that's before any loot is brought into the equation . . .

'Thus, since we have been singularly unlucky in discovering what those in our line of work like to call "a fat merchantman", we are bound to pursue the other professional economic means of your common-or-garden pirate—and that is: *We must search for treasure!'*

It was my bosun—Flatnosed Pete—who pointed out the basic flaw in my plan:

'But aren't we supposed to have a treasure map to start out with, Cap'n?' he growled. (He growled because of his terrible allergies, not because he was trying to sound like a lion or some other savage animal.)

'Usually,' I agreed, 'a map is the basic requirement for treasure-seeking, but I have decided to forego that initial stage of the exercise and move straight to the "landing on the island" stage.

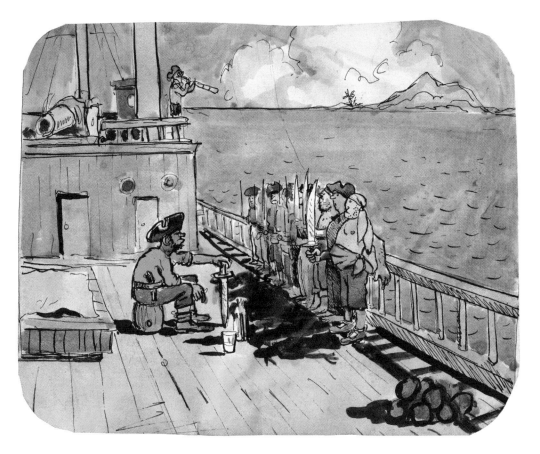

'It will be your job, Flatnosed, to take a small landing party to the island immediately behind you and to your right and see what treasure the place is likely to give up.'

'But,' says Pete, 'What if we don't find any doubloons, pieces of eight and so forth? What then?'

'Well, by Morgan's mussels,' says I, 'you'd better find us some fruit, meat, seafood and any other comestibles, or I'll have ye demoted to "second bosun". And you know what an unpopular job that generally is.'

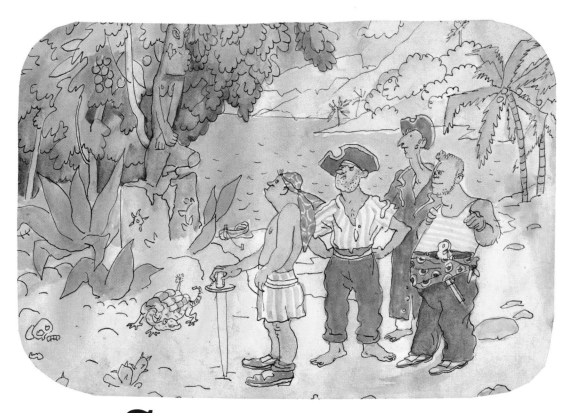

So off goes Flatnosed to the island without further ado, where he and his party almost immediately find a funny-looking ruin apparently of pretty ancient origin, being a bit like those idols discovered on Easter Island. Only this one is more interesting to them since it appears to be guarding a rather good crop of oranges, while other trees nearby had plenty of coconuts. These proved especially tasty coconuts because they were actually full of cocoa (well, all right, it was chocolate coconut milk, which is almost the same thing and very refreshing).

Pirates, being natural romantics, as I have already said, soon discovered the island's ancient ruin and began to speculate about its origins. Ginger Butcher, the ship's baker and candlestick maker, said he had studied anthropology while at pirate university in Port o' Spain and knew the category of the ruin. A sort of totem pole, he said, generally built by Native Americans, some of whom had migrated to the Caribbean several centuries earlier as wampum exiles. Very likely all the island's inhabitants had died out by now, but he thought it worth noting so took a small sketchbook from his pocket to make a quick drawing.

At this, Old Grumpy the second mate said the pole was an ugly-looking whatever-you-called-it. So, if it wasn't made of chocolate or cake, he wasn't interested.

Ginger, meanwhile, continued to mull over the identity of the people who had built the monument until the others got bored and went off to collect as much fruit as they could safely load aboard their longboat . . .

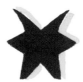

A bit later on, another hunting party managed to find some tasty game.

Soon the spirits of the pirates took a decided turn for the better. They decided to have a special Treasure Island Holiday, which is the same as a Bank Holiday for pirates, who tend to think of treasure islands much as some people think of banks.

They cheered up thoroughly and began to play traditional pirate games which included a blood-curdling oath competition.

The winners of the competition were Billy Belly, Ginger Butcher and Lanky the Scouser with the following oaths agreed by the other pirates to be most likely to curdle their blood (had they not been familiar with the swearers themselves):

First prize: *I'll tear out yer liver and eat it in front of yer!!!*

Second prize: *I'll screw off yer head and replace it backwards cross-threaded!!!*

Third prize: *I'll force open yer jaws and fill yer full of live jellied eels!!!*

They also enjoyed swimming, fishing and shooting at one another (which was dangerous and tended to reduce the size of the crew

until it was too small to be of much use).
They had found a horse on the island. He, it
turned out, was also fond of swimming and
took readily to the pirate life. It was clear he
had once been a performing horse of some
substance and skill—another mystery of the
island.

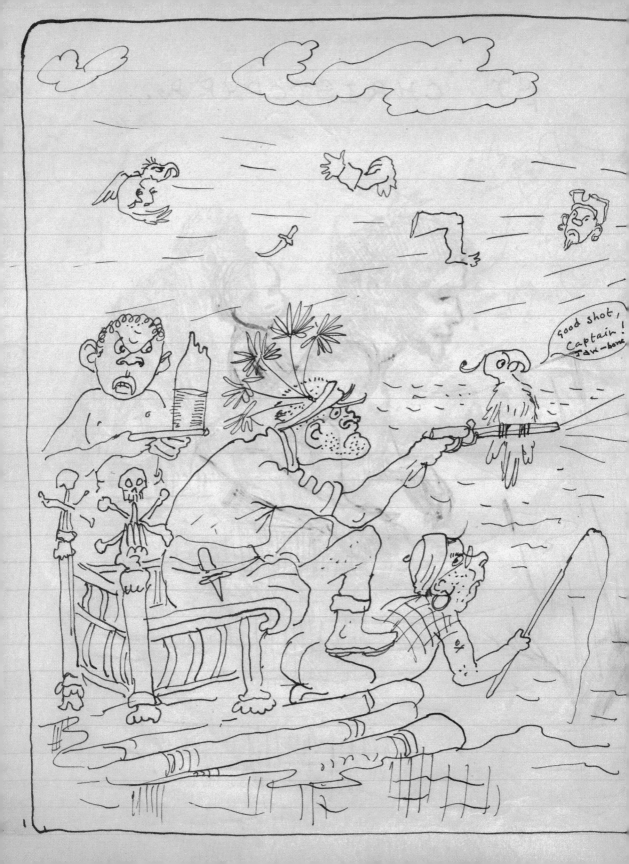

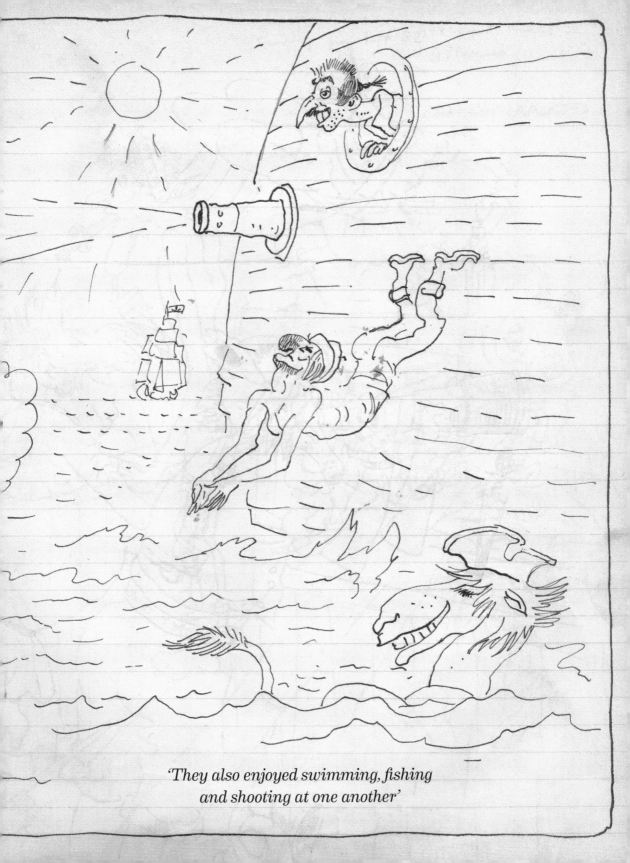

'They also enjoyed swimming, fishing
and shooting at one another'

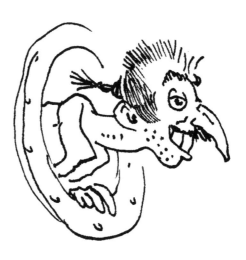

With such handy supplies of food and water, the pirates, being the feckless bunch they were, became so used to the leisurely life that they never noticed the one thing they had all been hoping to see on the horizon ever since they had made me their captain.

A sail!

Or, actually, a whole set of sails, belonging to a square-rigged, three-masted brig which had all the appearance either of a 'fat merchantman' or, perhaps not quite so welcome, another pirate ship.

They went on enjoying themselves and I must admit I did the same. The pirates were becoming quite good professional entertainers. For instance, this pair. What were their names? Well, here's a little song we sang about them:

LANKY & MONTY

Lanky the Scouser
Never wore trousers
His underpants were always clean
His socks, I must say,
Were rarely that way
And smelled like a pot of sour cream

His pal Monty Funky
Had a rather fine monkey
Who played the squeezebox like an ace
For one cube of sugar
He'd entertain the whole lugger
With his tail up in poor Monty's face.

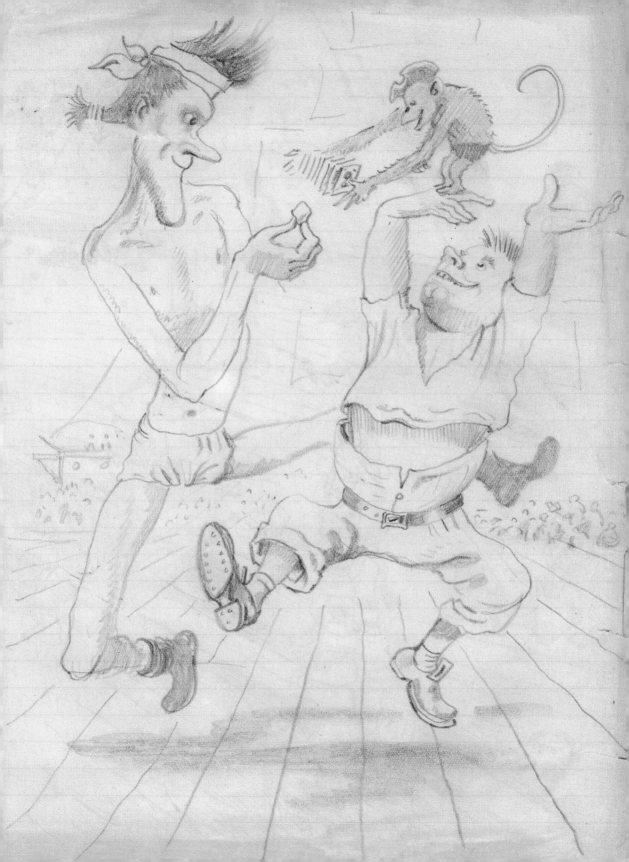

At last, however, the pirates spotted the rival ship and lined up at the rail to look. Some of the other pirates were still oblivious of what had come over the horizon but the ones interested included:

(reading from left to right)

Trumpet Truro

Flap Ears

Gloomy Gus

Lanky the Scouser

Titch

Old Shut Eye

Captain Crackers (I had meanwhile had a shave, or course)

And Bill (who was the ship's lucky black cat).

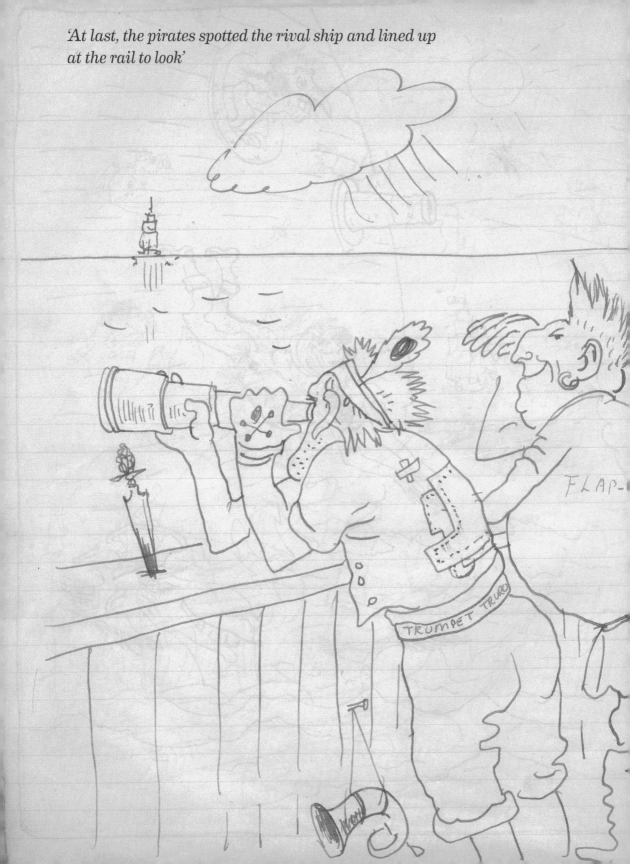

'At last, the pirates spotted the rival ship and lined up at the rail to look'

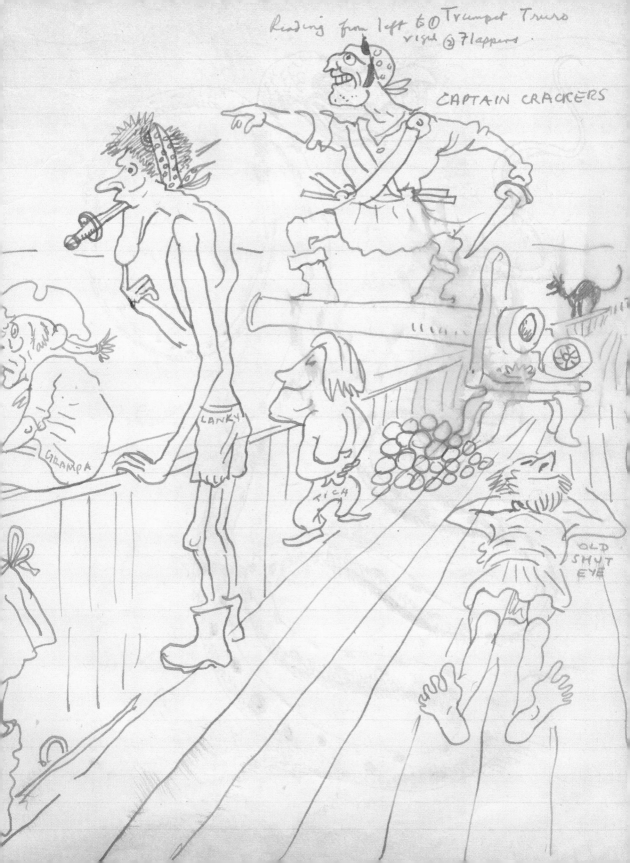

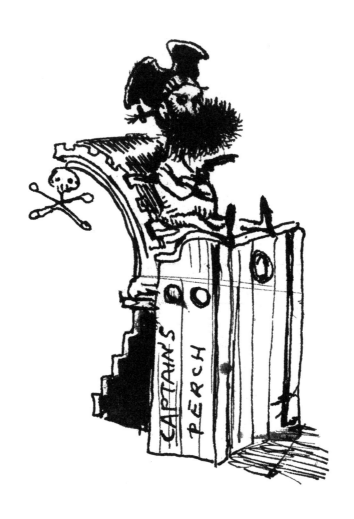

The ship turned out to be a fairly famous old privateer known as *The Fighting Eagle*, commanded by Captain Perch.

And, in true pirate tradition, the ships began to fight at the first possible opportunity and for no good reason.

The problem was, of course, that neither crew had had much practice at fighting and so forth and weren't especially expert at it any more. You'll notice, for instance, that some of the crew of *The Fighting Eagle* had already erected planks on the starboard (or possibly port) side of their ship and were walking them themselves.

All in all, as sea battles go, it was a bit of a fiasco.
In fact, there was no conclusive victory and I'm not sure exactly what became of *The Fighting Eagle* or her crew.
I think we can leave them at it for a while, since at least they are enjoying themselves . . .

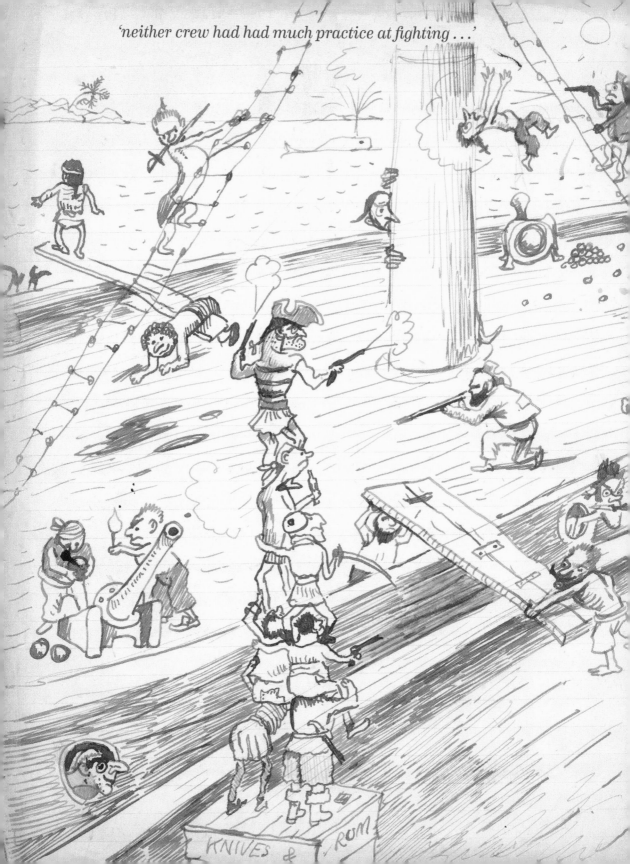

'neither crew had had much practice at fighting . . .'

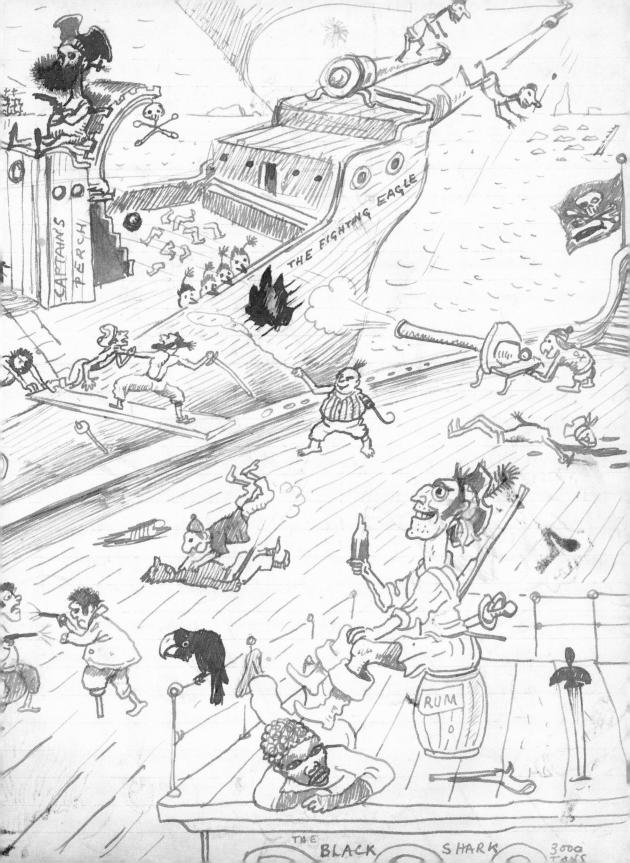

Meanwhile back on the island where no treasure had been found . . . some strange-looking animals were turning up, whose origins added further the mystery to the island.

At this point it might be worth discussing the different sorts of mysterious island—*desert*, *inhabited* and *treasure* being the main three. Of course the desert or generally uninhabited form of island can also contain treasure, but generally an inhabited island isn't deserted and vice versa, though treasure is sometimes found on both. If you happen to live *on* an island—one like Sark, for instance—and haven't turned up much in the way of treasure at home, you often have to leave your home island to look for treasure on other, wealthier islands (like Britain, say). You might have to go to London for a bit, or Paris or New York, to find enough treasure to pay for growing children. You'd have to leave, say, on Monday and not be back for a week or two. Meanwhile, those children might like to make an inventory of what was also on the island the pirates had discovered.

We should now, however, give some of our
attention to the narrative of Chief Wampum
Scrumpum, whose people actually had been
wrecked here years ago when their ship, part
of a Wild West Show, a mixture of a circus
and a menagerie, ran on the rocks of our
island.

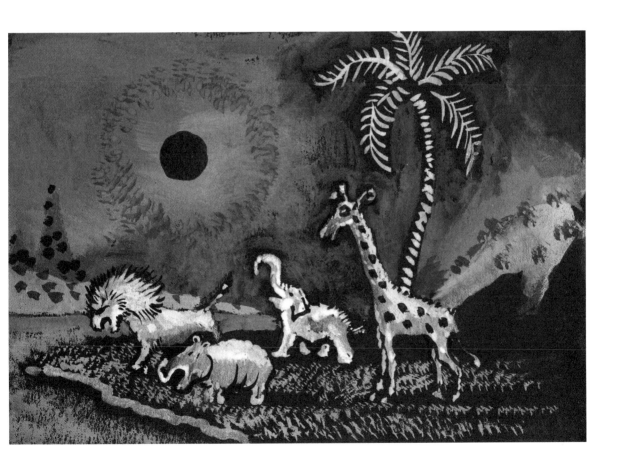

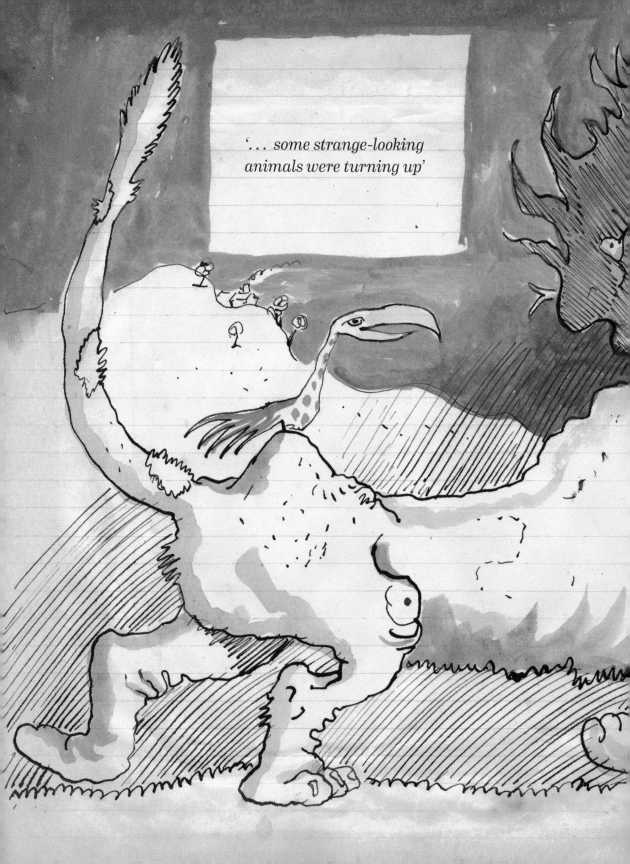

'... some strange-looking
animals were turning up'

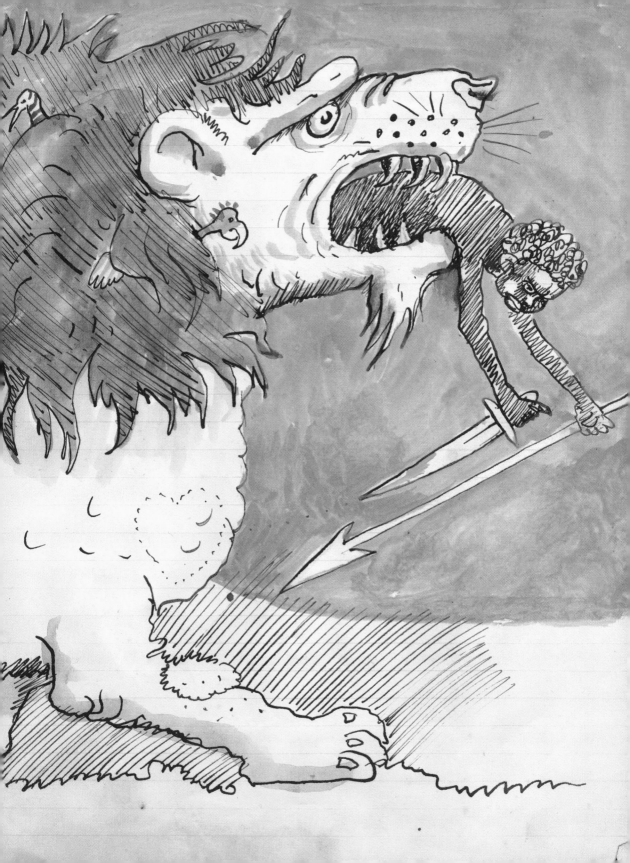

I shall call this:

THE SHIPWRECKED CIRCUS: OR, THE DESERT ISLAND REDSKINS,

As narrated by Chief Wampum Scrumpum himself

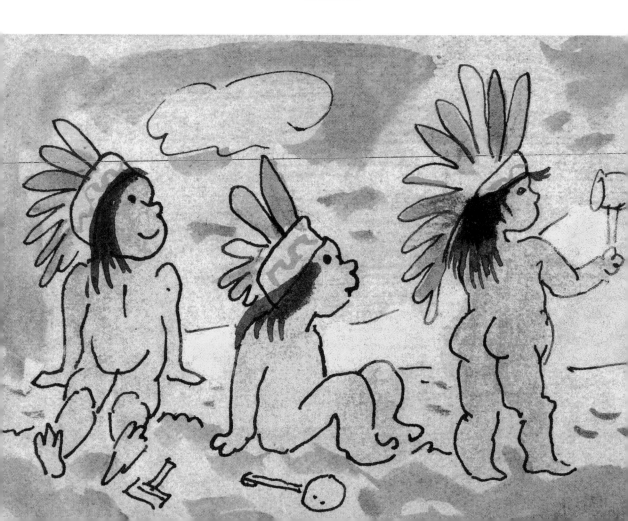

My early years, before I joined
the Wild West Show, were idyllic.
That was before my show was ship-
wrecked and I met the infamous pirate
chief, Captain Aloysius Crackers. My tribe
had erected our wigwams beside a lake
that absolutely brimmed with tasty
fish. There was all kinds of game
to eat and, yes, since you ask, I did
have sons. I had triplets named Little
Bear, Little Deer and Little Kid.
They were extremely well-behaved
boys and I smiled on them with pride
from dawn until dusk. (When, that is,
I wasn't having to go away from the
camp to do some hunting and bring
back food for us all to eat.)

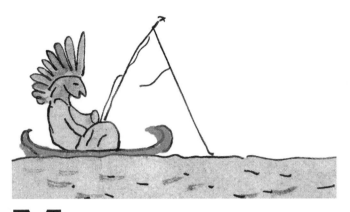

My uncle, Bigfoot the Blackfoot, was
very good at fishing and went out every day
in his canoe to bring us back a variety of tasty
piscines. These we ate with chips. Not with
buffalo chips, which good taste forbids me
from describing here, but with potato chips.
Potatoes, you will recall, grew in abundance
in North America, my original home.

We also ate sweetcorn and tomatoes and we
smoked tobacco, three other enjoyable crops
that could be found wild all along the shores
of Lake Mickey-Ho-Ho.
Mickey Ho-Ho, our legends said, had once
been the husband of another well-known lake
called Minnie Ha-Ha. Named for these twin
lakes, Mickey and Minnie were two legendary
Native Americans who became famous all
over the world and were, so I have heard,
amongst the first great film stars.

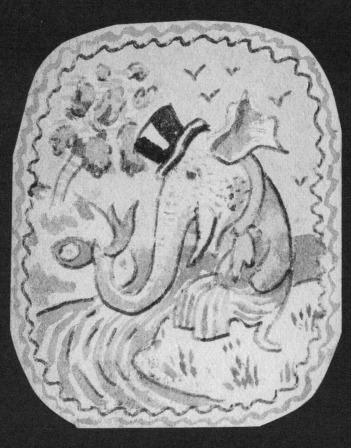

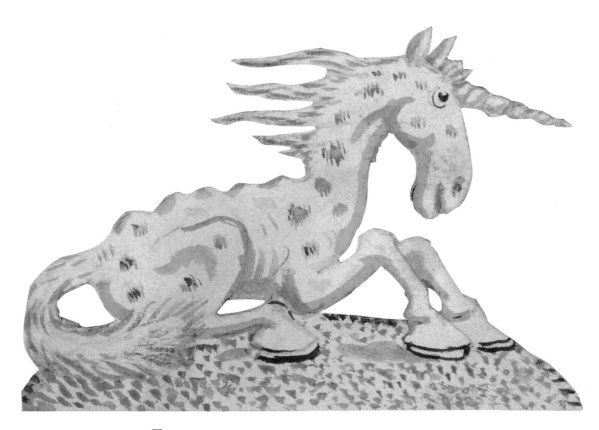

As luck would have it, I was a little bored with my idyllic life beside the lake. One day a steamship came by recruiting people to feature in Dangerous Dan's Famous Wild West Show. I grew so fascinated by one of the animals, the extraordinary unicorn, Oona, that I signed up myself and my sons as a general whooping, stomping, bow-and-arrow-shooting 'Red Indian' act and off we went to sea.

To my dismay, Oona the unicorn turned out to be a perfectly ordinary performing horse, painted white and dressed up with a fake horn. He wasn't even a girl. His real name was Geoffrey. He had been the property of a famous cowboy outlaw called 'The Masked Buckaroo', but they had become separated when they fell into rapids not far from Lake Minnie Ha-Ha. Now Geoffrey had no idea where his master was.

And so I began my life as Big Chief Charabang and his Famous Shooting Braves.

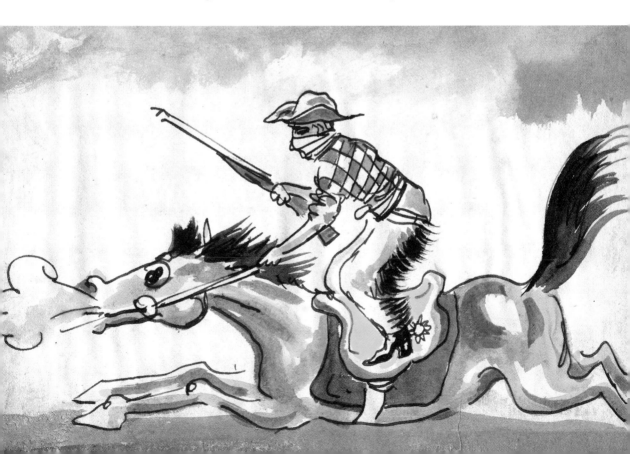

'a general whooping, stomping, bow-and-arrow-shooting "Red Indian" act . . .'

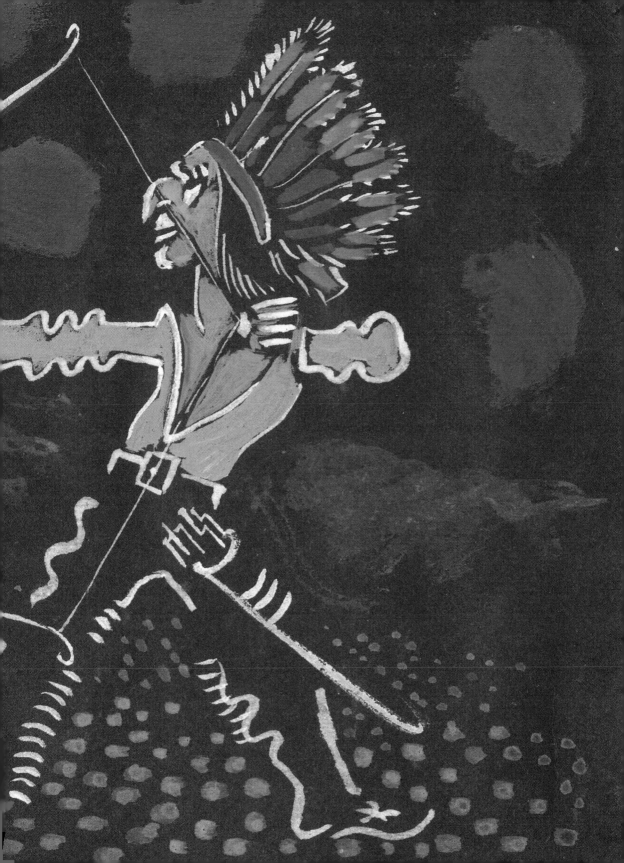

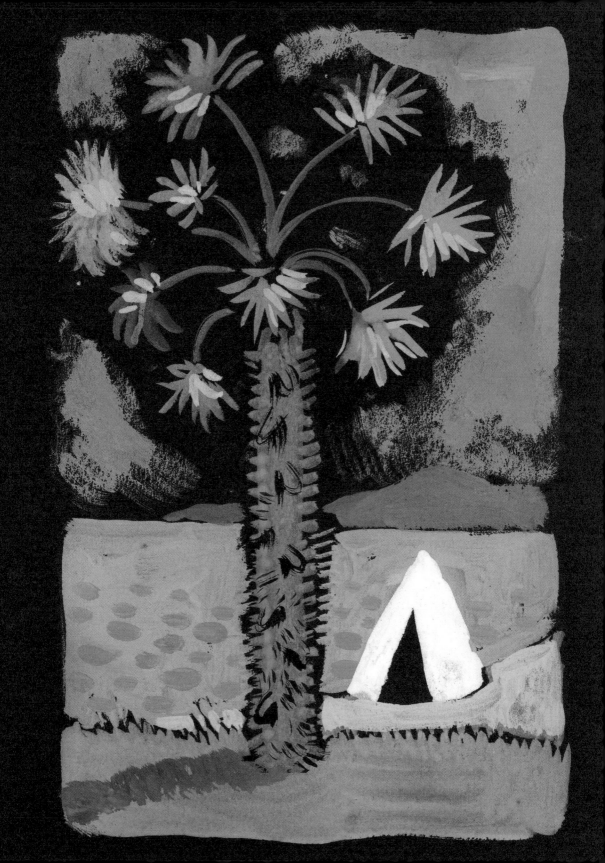

Returning from a tour of Europe, the circus ship was wrecked on a lonely Caribbean island. Soon my wigwam was raised not beside the peaceful waters of Lake Mickey Ho-Ho but under alien skies and the spreading branches of a coconut tree.

Beyond the fronds of an old palm tree
Lies a mysterious ocean (one of three)
And on it, beneath the mighty moon,
I whistle a strange and romantic tune
And tell the tale of a prairie green
And a lake as smooth as dairy cream
Of the bravest young cowboy who had nothing to do
But ride and shoot and whoop and yell
(Believe me, dear friends, he did this well...)
It's the thrilling tale of The Masked Buckaroo
And if you knew it, you'd tell it, too!

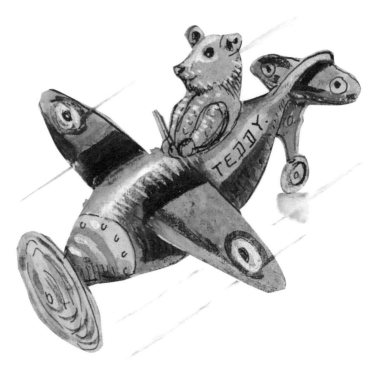

The animals and some of the other acts
were scattered across the whole island,
including the performing lions who could
sometimes be heard roaring from the forest.
Every few months an RAF plane flew over,
spotted a strange animal and picked one up,
but I was never in the right part of the island
to take advantage of the flight. Still, I was
happy enough . . .

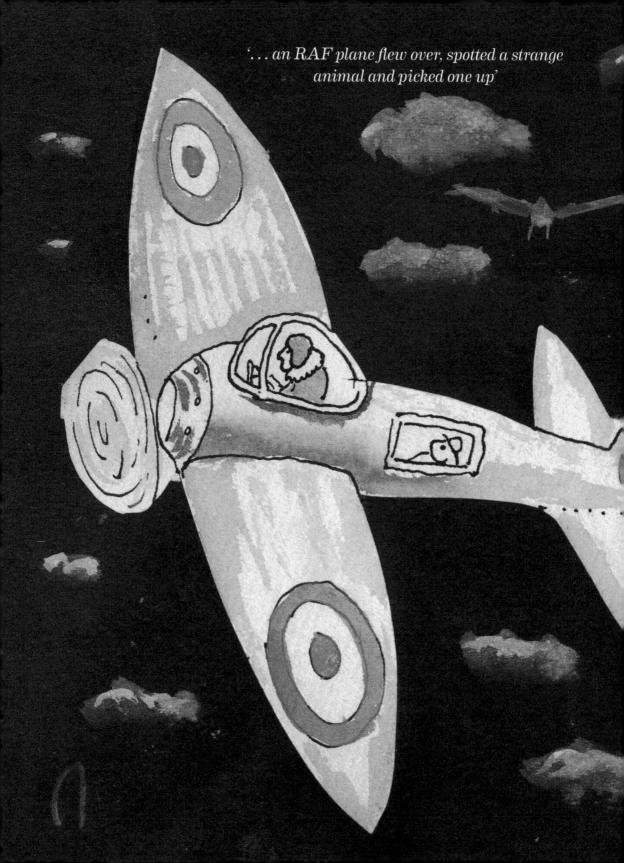

'...an RAF plane flew over, spotted a strange animal and picked one up'

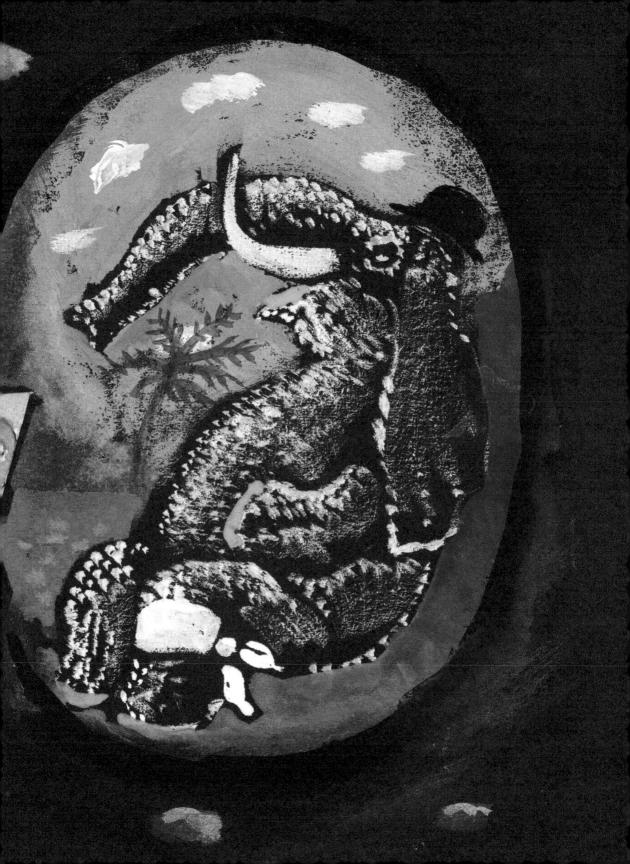

We soon all settled down to make the best of our lives on the island. I adopted a dwarf called Old Hairy Face. He was a very good hunter and brought us plenty to eat in return for being bathed once a week.

With his tame *wochermacallit* bird, which he
had trained to the saddle, Hairy Face aroused
some jealousy in The Masked Buckaroo
who occasionally rode by shooting his gun
in a decidedly petulant way. He was not
dangerous, of course, and sometimes together
we played games of polo or Island Scrabble.

Island Scrabble is a rather simpler version of
the usual game. We had only been able to
rescue twelve letters from the shipwreck. But
that was all right because generally speaking
neither Old Hairy Face, The Masked Buckaroo,
my three sons nor myself were very good at
spelling and we liked to keep things simple.

The brightest and best person on the island
was Toddle the Turtle, who would have
beaten everyone at Island Scrabble all the
time had he been able to hold the letters with
his flippers. Toddle could still be cajoled,
however, to help one or another of us out
when it came to finding words longer than
three letters.

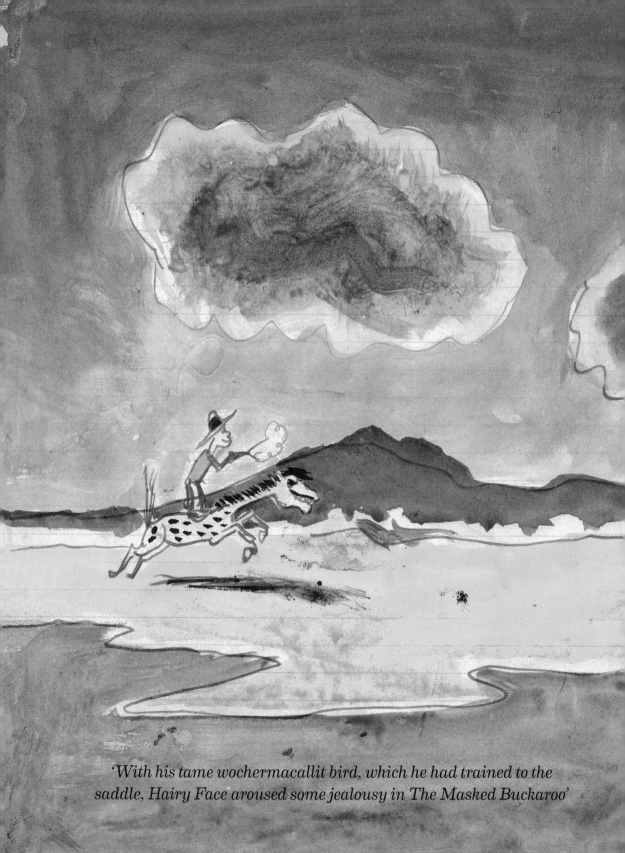

'With his tame wochermacallit bird, which he had trained to the saddle, Hairy Face aroused some jealousy in The Masked Buckaroo'

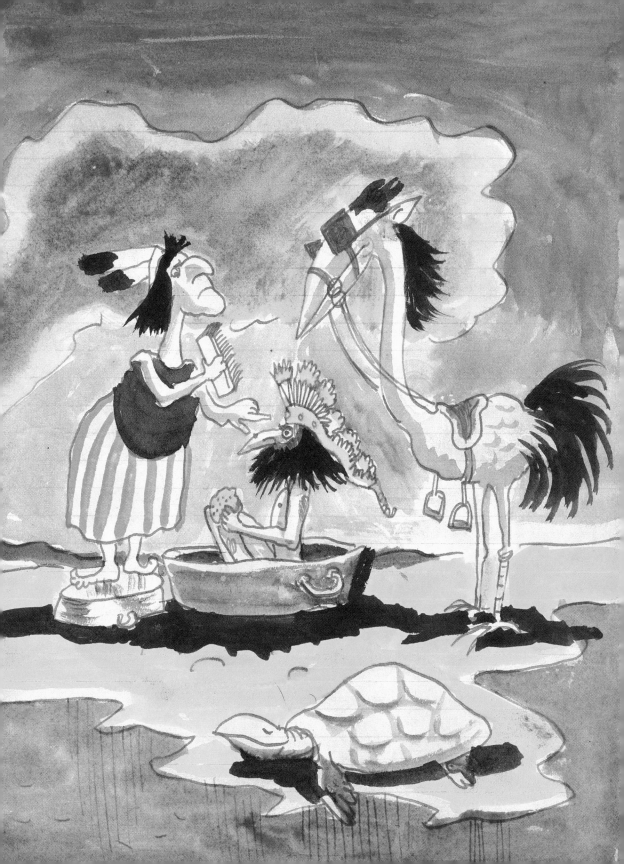

So happy did we become on the island, in
fact, that we really didn't notice passing ships
and forgot about being rescued. Instead
we built ourselves some log cabins and
other houses to taste. We played with all
our various friends.

Soon they intermarried and produced some
very strange children which Mr Darwin
would have found fascinating.

Since we were already very fit and didn't have
to ensure the survival of the fittest, we only
pretended to hunt one another.

The snake, for instance, had a rabbit wife
whom he carried with him everywhere. The
cats built nests in trees and sometimes gave
birth to birds, while the owl found himself
the patriarch of a rather large family of
elephants.

For my own part, though I knew I was the
father of the triplets, I wasn't altogether sure
about who my other children were.

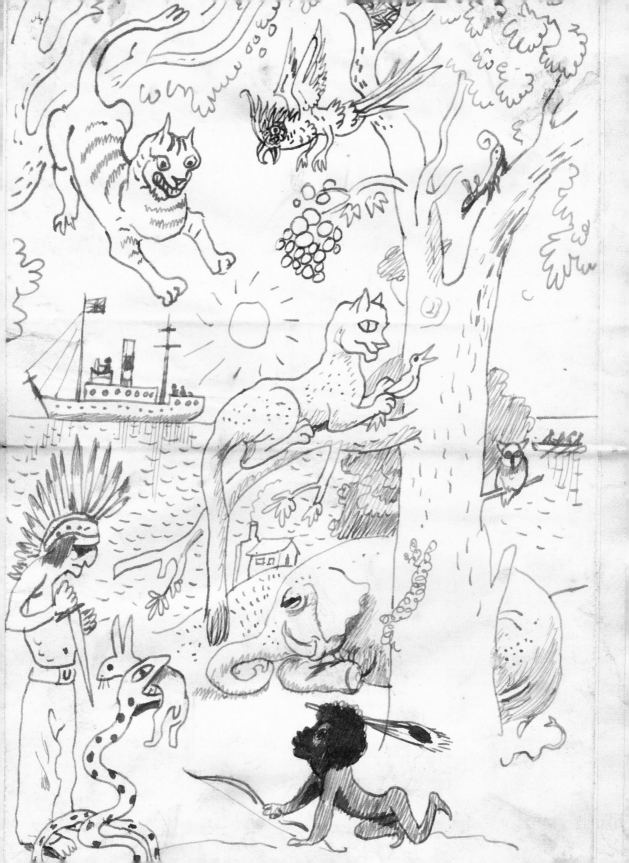

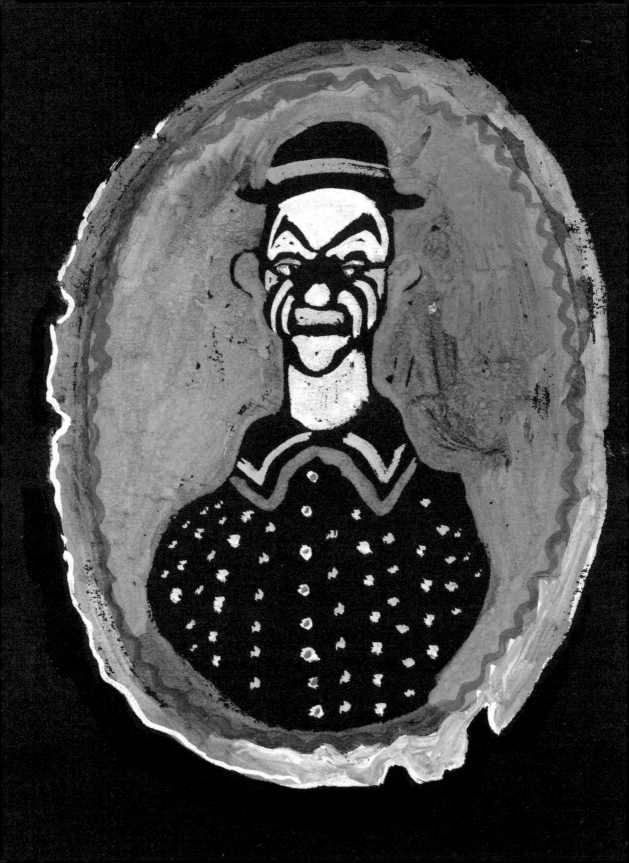

This arrangement proved of no particular consequence to the majority of us except to Grumpy, the disconsolate clown, who had not been happy even before he came to the island. He spent most of his time singing the gloomier arias from *Pagliacci*.

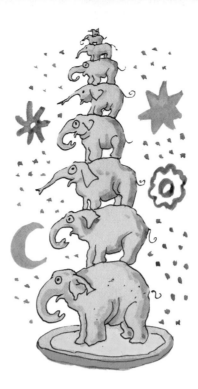

Luckily for us, the owl's elephant family, still with a considerable amount of owl blood in their veins, proved to be natural humorists and were forever entertaining us with their antics. They would have been absolutely perfectly happy had it not been for one thing . . .

They were all desperately in love with the same beautiful giraffe, called Petronella Gullybucket.
I must admit I was a little in love with Miss Gullybucket myself, having left my Indian wife behind at Lake Mickey Ho-Ho, but not as much, of course, as I remain in love with that beautiful and forgiving woman.

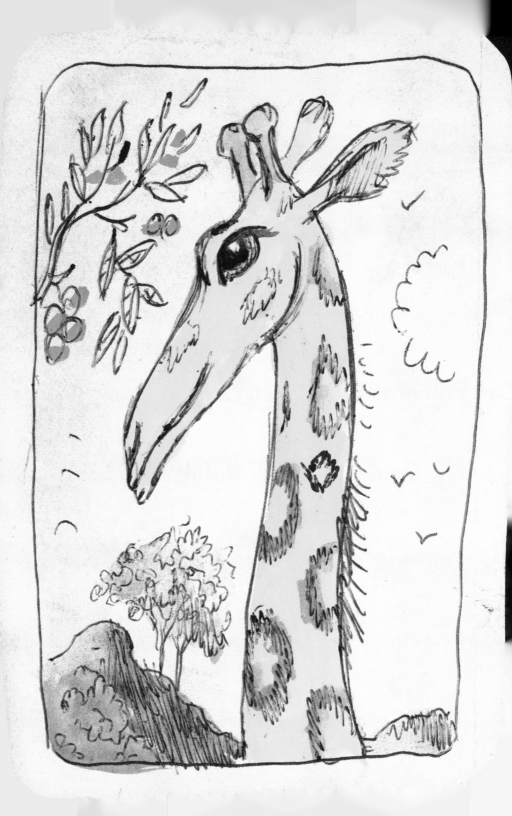

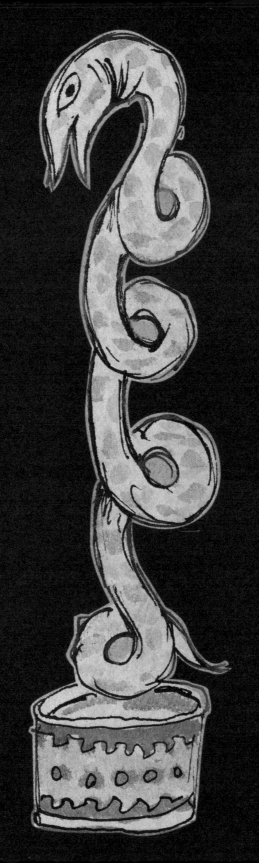

While we had no radio, films, theatre or concerts, life was never dull for long. Our days passed pleasantly enough for us all, and we lived mostly on fish, chips and puddings which in fact became world-famous. We traded them with local people. The elephants were especially keen on getting new hats and would give up their whole pudding ration for one.

The performing snakes found puddings a bit heavy, especially when they tied themselves into difficult knots, which gave the rest of us something to do, especially those of us who had fingers.

We put on shows for ourselves. These became increasingly elaborate. I thought them rather impressive.

And so our idyllic existence on the island would have continued, had it not been for . . .

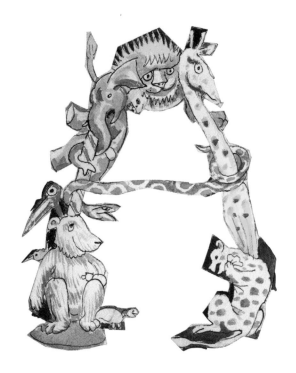

(. . . and now we bring our two tales together again!)

. . . our discovery by pirates from the ship called *The Black Shark.*
Whereupon we were forced to defend ourselves. They were clearly pudding hunters, anxious to steal some of our famous duff for their Christmas feast. We would cheerfully have given them some, had they asked, but they preferred to fight . . .

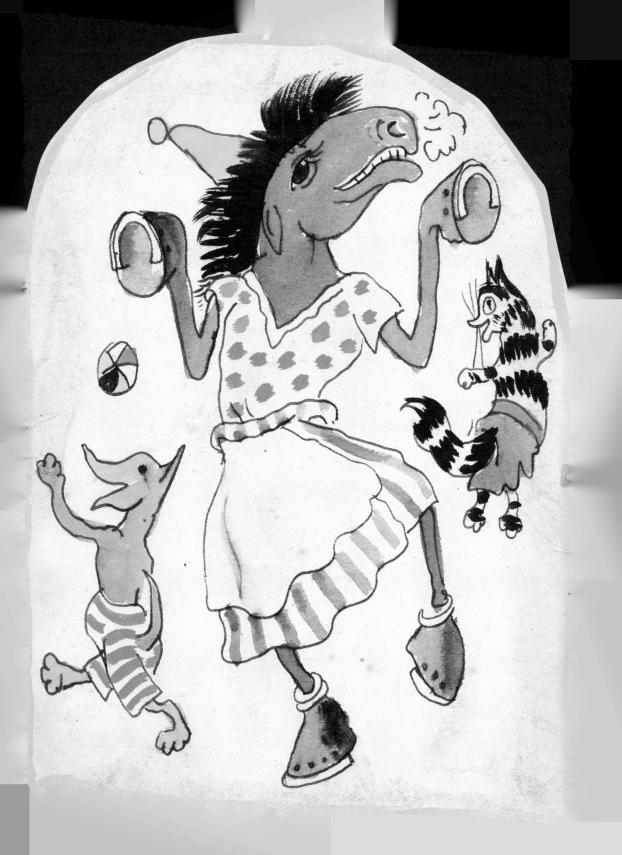

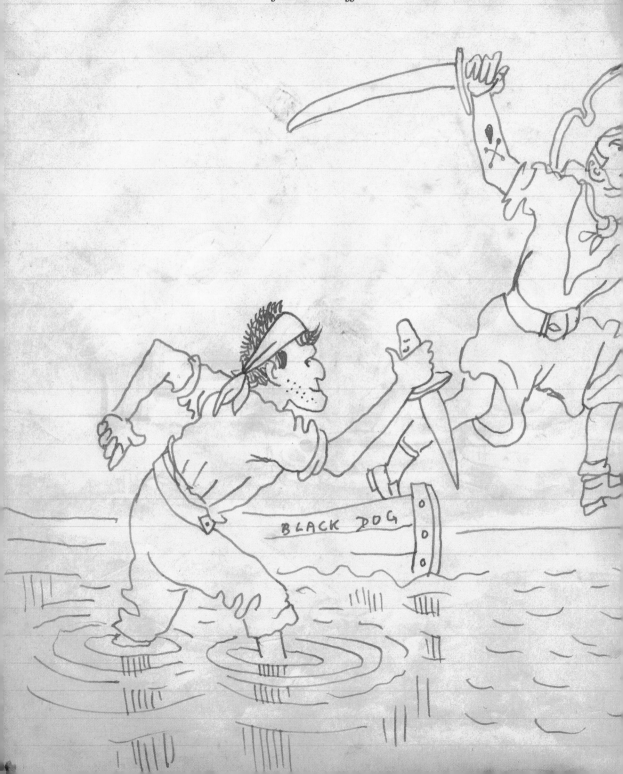

'They were clearly pudding hunters, anxious to steal some of our famous duff...'

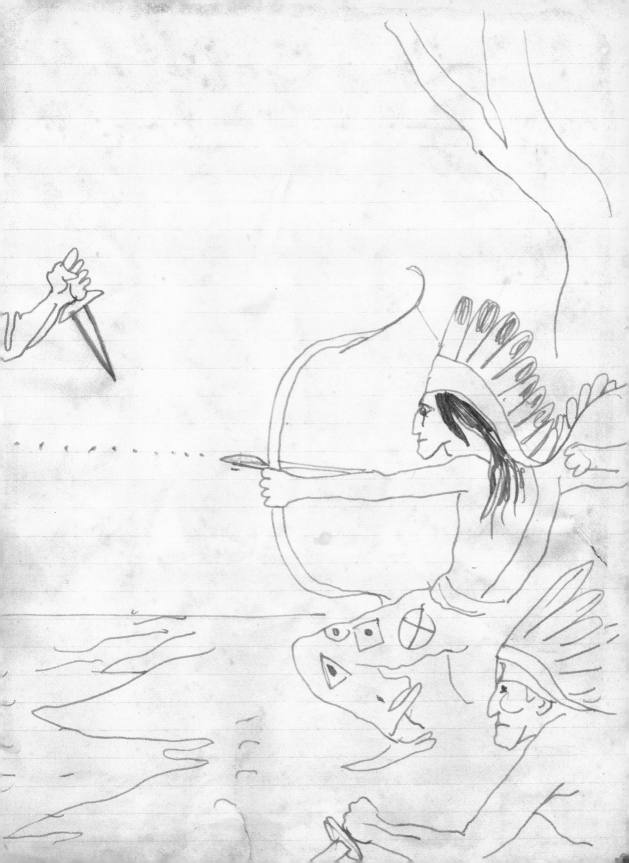

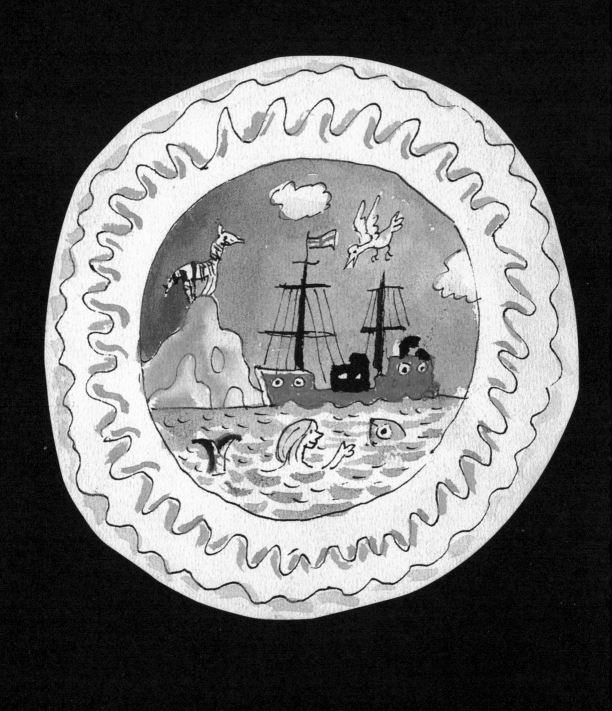

Matters might have gone badly for us had not our mermaid swum for help while our zebra signalled from a high point on the shore.

A British police steamer chased the pudding-laden pirates away just before Christmas Eve and peace returned to our island.

And so ends my narrative. We have since not been troubled by pirates but now bury our spare puddings in brass-bound oak chests, just to be on the safe side. We make maps of where the chests are buried, of course, but I must admit we frequently lose them.

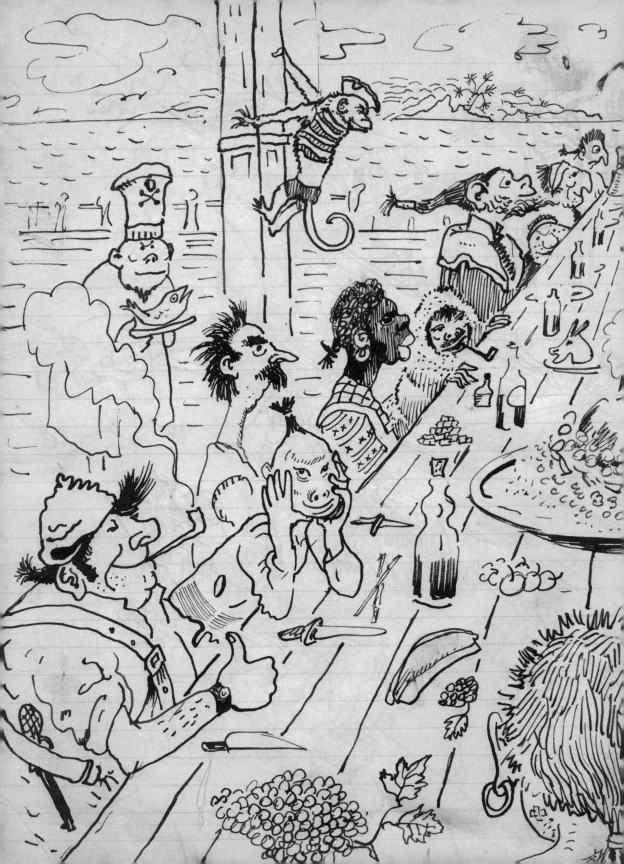

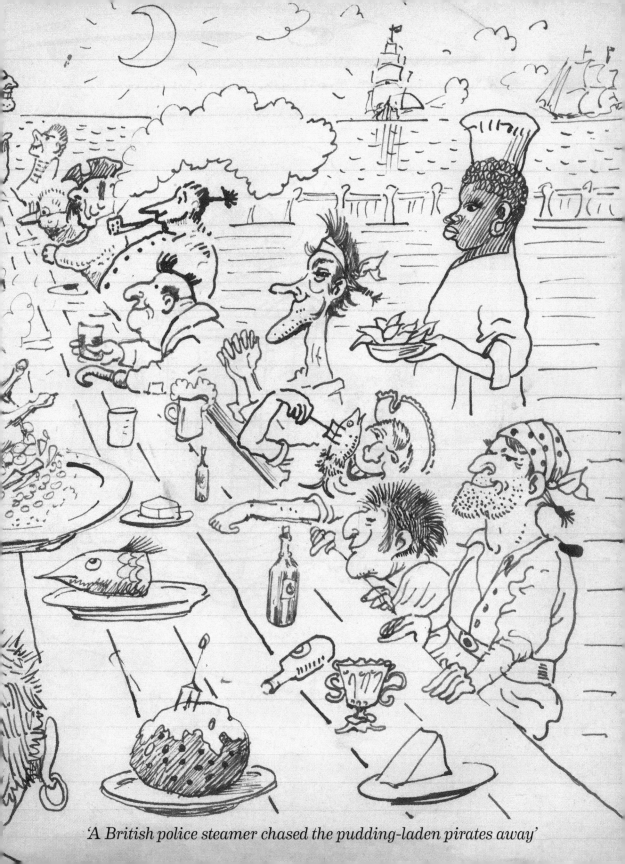

'A British police steamer chased the pudding-laden pirates away'

(We return to the narrative of Captain
Aloysius Crackers . . .)

Meanwhile, I, Captain Crackers, had
done right by my men. I had promised them
puddings, turkey and duff for their Christmas
dinner, and puddings, turkey and duff they
should have.

This was to be a touching moment, when I
bade farewell to my crew. I planned to return

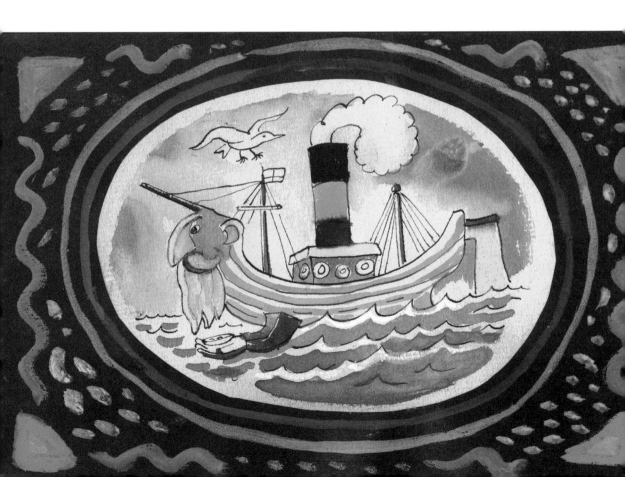

to civilisation with the treasure we had divided up from our successful battle with *The Fighting Eagle* and there purchase a small cruise liner which would take pensioners on old-time dancing holidays where they could do foreign foxtrots, waltzes, two-steps and fandangoes to their hearts' content.

But the crew demanded one final treat. They begged me to take them to the Nightmare Races, which I had told them about, having attended one of these events in my early years in Kent. They had been a loyal crew, so what could I do but agree ?

The Nightmare Races are held once a year on All Hallows' Eve. They take place at Badwood, Sussex, England, beneath the light of the moon if there is one. The main race is for the Engelbrecht Cup.

It's anyone's guess which grotesque runner will win—or who will win the pot of black gold dug up from the end of the black rainbow. Black gold is these days worth even more than the ordinary yellow kind.

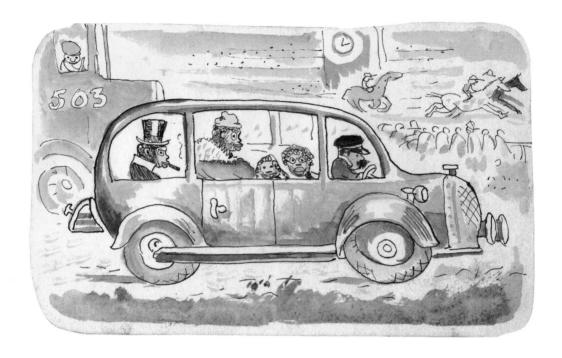

Arriving at the races, I put a Spanish doubloon each way on Jocko the monkey and his horse Igor . . .

. . . a German thaller to win on Winnie One and Winnie Two—the Apache and his horse

. . . and another gold Louis on the nose of the parachute mouse as a long shot.

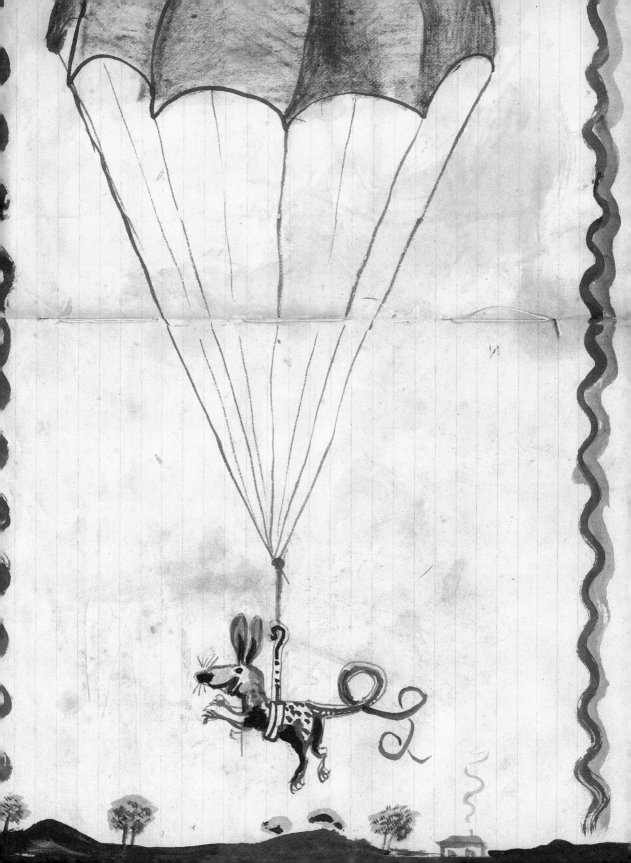

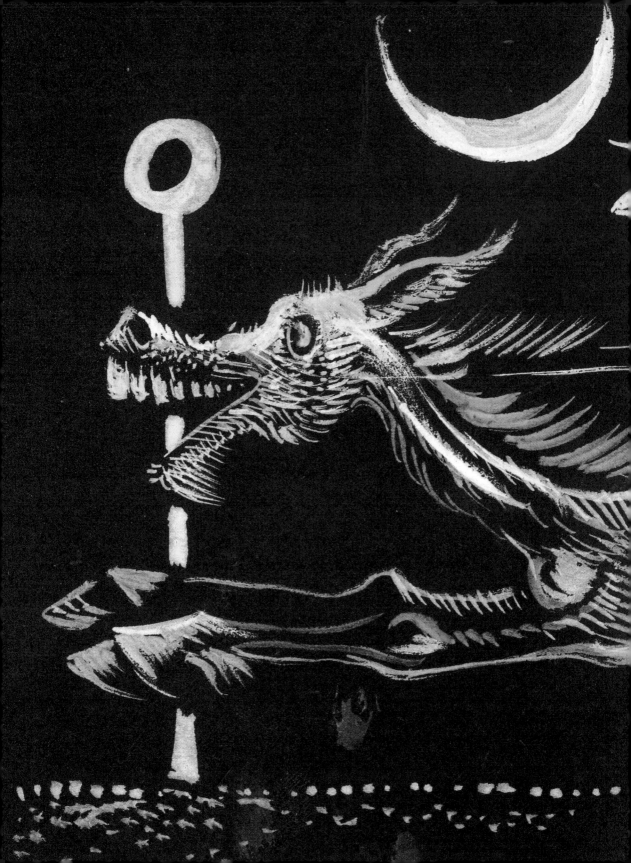

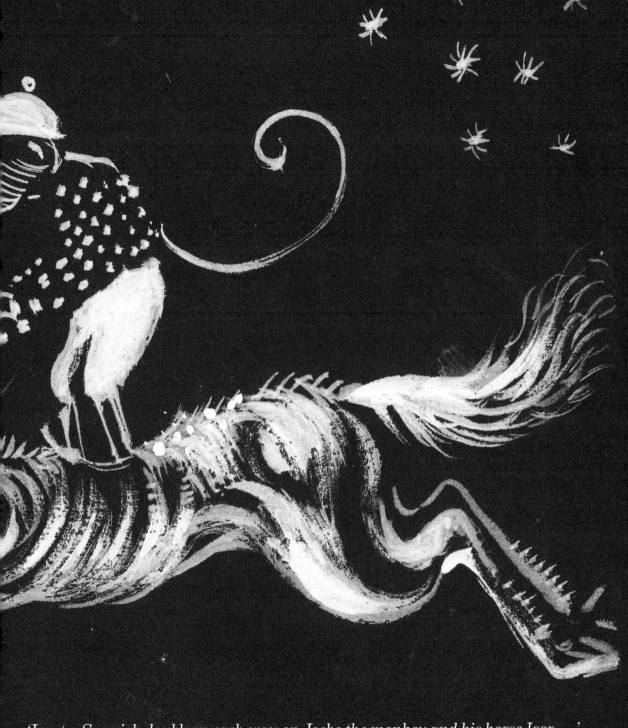

'I put a Spanish doubloon each way on Jocko the monkey and his horse Igor . . .'

Though I didn't expect anyone to win but
the horse, the dog and the cat were strong
swimmers in the Badwood water races known
as the 'Ditch to Ditch'.

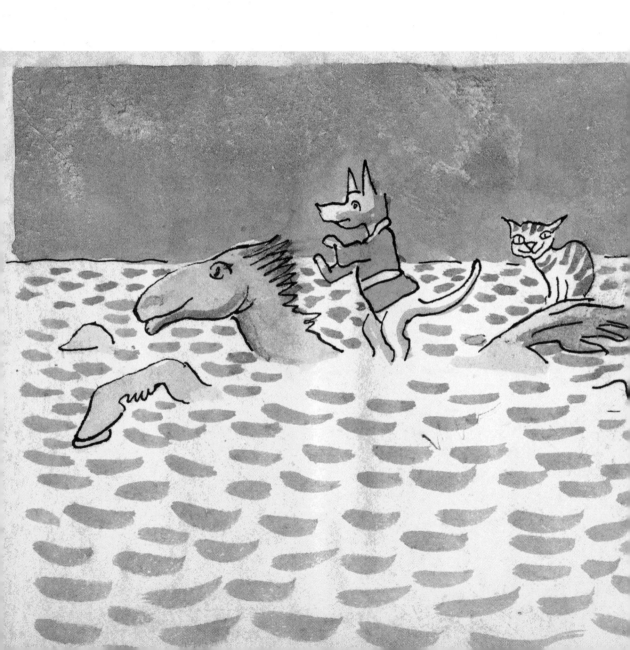

At the last minute I put a few pieces of eight on The Masked Buckaroo, who was a late entry, having come with us from Pudding Island and with whom I'd made friends on the journey. To be honest, I was feeling a bit guilty about plundering the puddings and hoped I would win enough money to give The Masked Buckaroo to take back home with him and pay the islanders for their extremely tasty desserts.

The Nightmare Races were once run by real mares who only appeared at night, but they changed the rules as electricity brightened everything up. As the old song has it . . .

The Nightmare Races are nasty and dark
On Walpurgis night at Old Badwood Park
They are galloped by skeletons, witches or demons
(You can back them all ways—odds,
neutrals or evens)
They are run by Indians, cowboys and sharks
Are the Nightmare Races at Old Badwood Park.

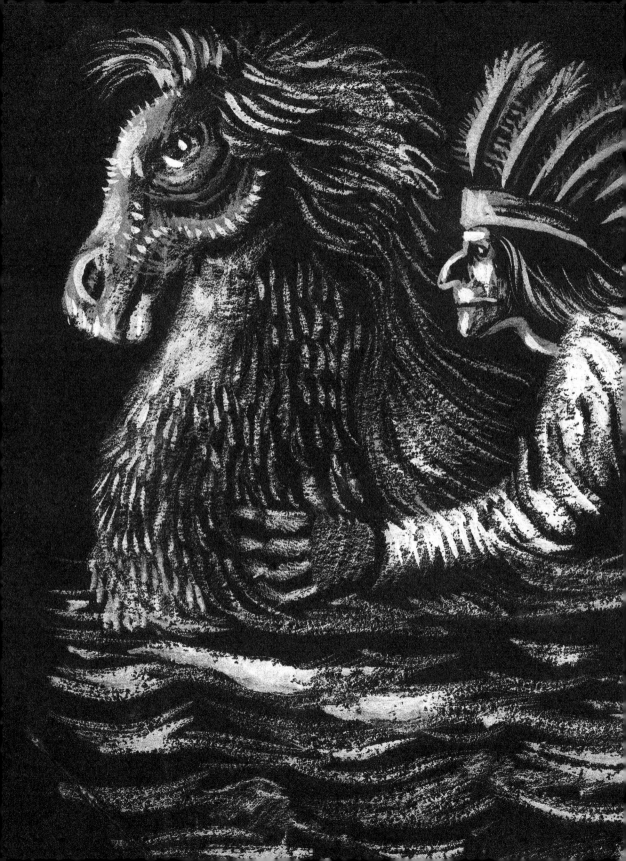

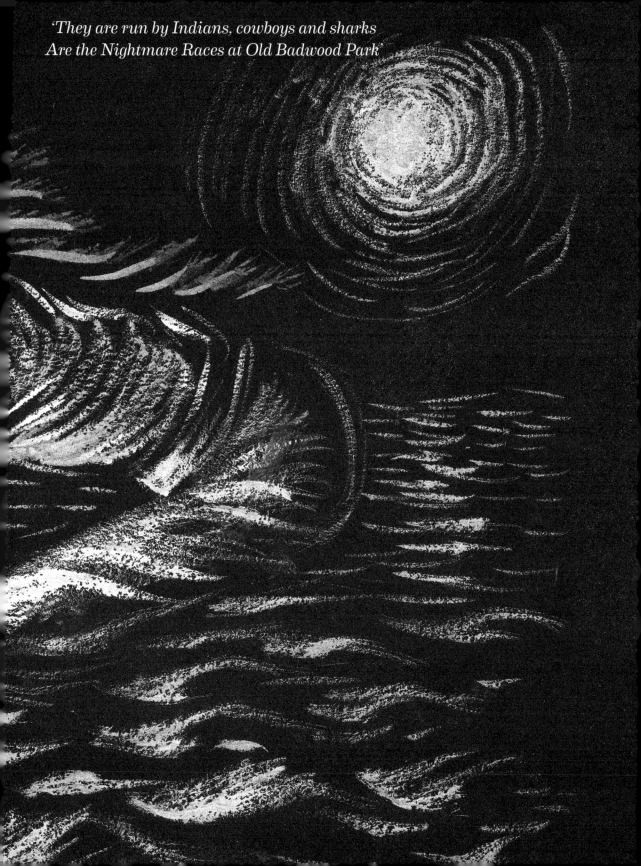

'They are run by Indians, cowboys and sharks
Are the Nightmare Races at Old Badwood Park'

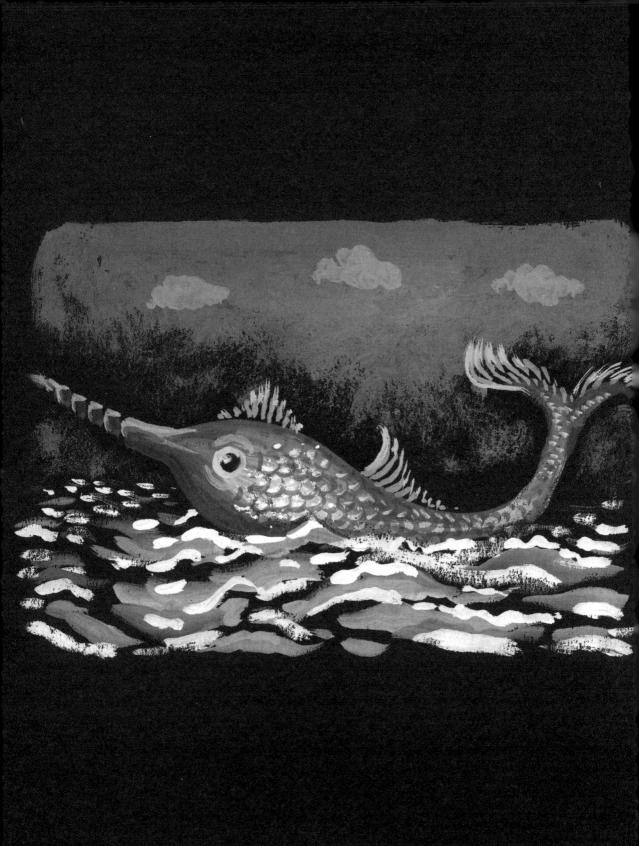

It was an exciting night, with several races being very tightly contested.

Believe it or not, I backed the screw-nosed haddock a guinea each way in the Ditch to Ditch—and she placed second!

I backed The Masked Buckaroo in the two-thirty and I got two dozen pieces of eight for four when he won the four-fifteen!

My crew were equally lucky, so we happily agreed we'd had a very profitable and enjoyable night all round!

(Can *you* tell me how much two dozen pieces of eight for four works out at?)

The Masked Buckaroo very graciously agreed to take some of our winnings back to Pudding Island in return for our booty, and I paid a tearful farewell to my crew, who had decided to try another advertisement for skipper in *The Corsair Gazette*.

Then I was off to Saint-Malo in France
where I'd had news of a very nice little cruise
liner being up for sale.
And that, boys, is how I spend my time. My
liner's in the harbour at Sark even as we
speak, but I'll have to be back on her again
by nightfall. I should be passing this way
in a week, however, and hope to see you
again then.

Meanwhile, I leave you with a few of the
shanties, reels, hornpipes and doggerel verse
I picked up on my travels in some of the
strangest parts of the world.

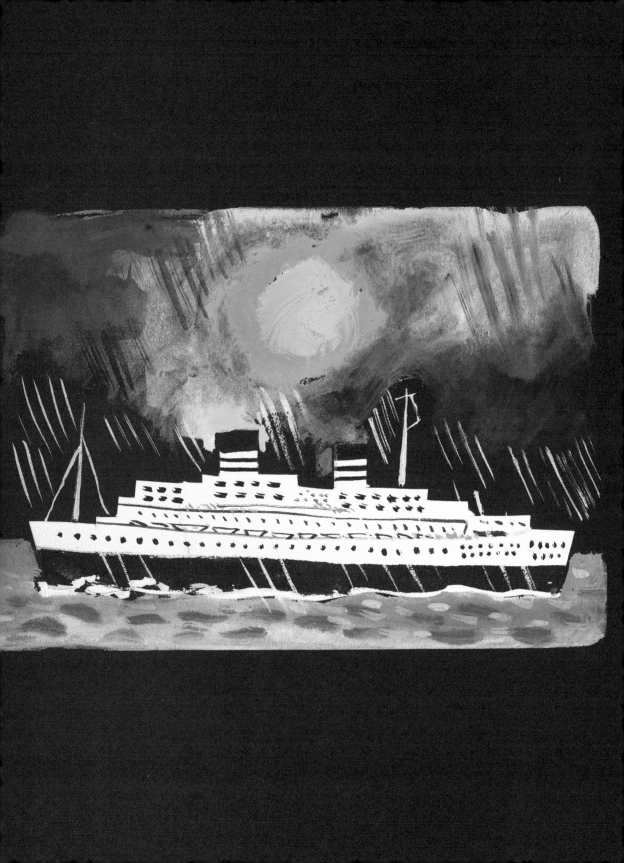

DR CARROT'S GOURMET PARROT

Dr Carrot had a parrot
(or maybe he was a myna),
He taught him to speak
In Hindi and Greek.
No parrot could enunciate finer.

Then, one terrible day, he flew far away
(Doc thought he made it to China),
And when he returned
(no new language learned),
He'd become quite a fine gourmet diner.

So thus in the end Old Doc C kept his friend
Though the food bills soared
higher and higher,
True, that bird grew to demand
Wild salmon (not farmed),
But he sang like a whole Sunday choir.

'Dr Carrot had a parrot
(or maybe he was a myna)'

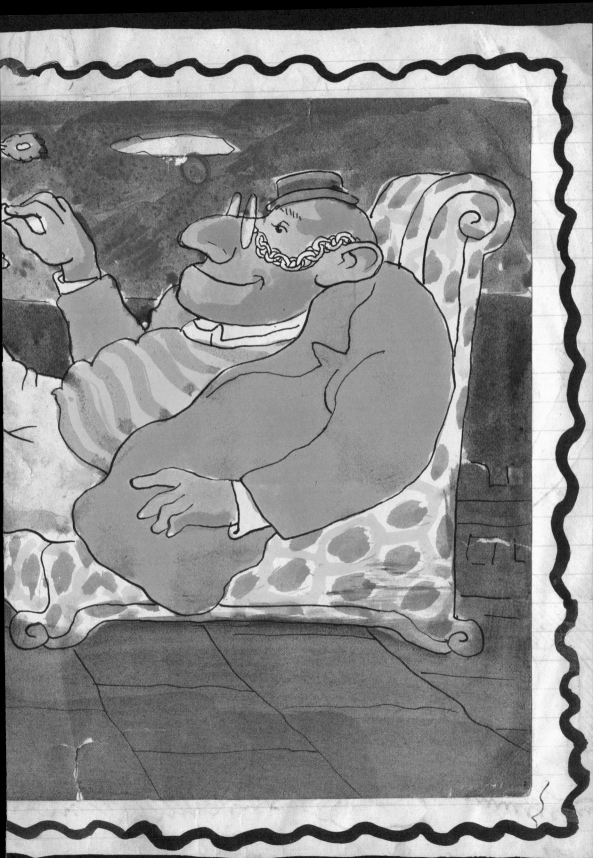

THE WINGED TERRIERS
OF ANGOULÊME

In a town made famous by Balzac (Honoré)
And a comics convention (that is *bande dessinée*)
Lived two famous animals, terrier tykes
Who had miraculous skills (they could even ride bikes).
But their strangest of traits, about which everyone sings,
Were the growths on their backs (these little white wings).
Some folk thought the doggies sent by God from above,
For all Angoulême to support and to love,
But the priest, though quite liberal, said that it was not likely
That the Lord should disguise angels in bodies that tykely.
But soon the city accepted the care
Of two glorious dogs who could sail through the air.

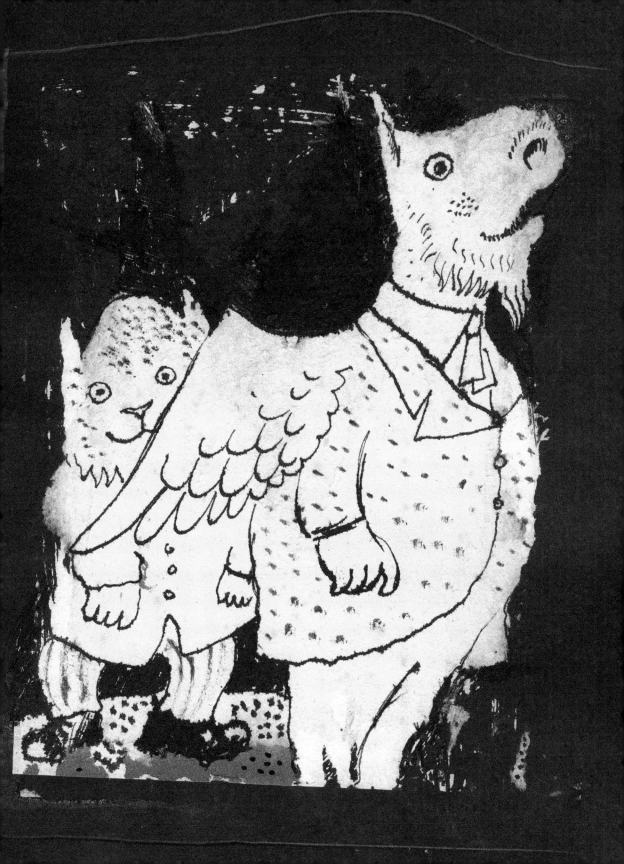

And so with a few more songs on his lips, Captain Aloysius Crackers packed away his drawing and writing materials into the old sea-chest, promising to return soon and regale the two boys with more stories and pictures. They would have started to miss Captain Crackers had not, a few moments after he had gone, their mother called them in to tea. And who should be there, about to cut the cake, but that dad of theirs. Sebastian told Fabian that he thought he had unravelled the mystery of Captain Crackers. 'He's dad's brother,' he said. 'It's just that he's a bit embarrassed to admit it. After all, what's our dad ever done that was really interesting?'

The Dunce

Born in 1911 in China to missionary parents, Mervyn Peake was brought back to England in 1923. After studying art, he became a painter, illustrator and costume designer. His first book for children, *Captain Slaughterboard*, appeared in 1939. The next year, he began writing *Titus Groan*, the inaugural book in his Gormenghast Trilogy. He joined the Royal Artillery and in 1945 he was the first war artist to visit the Bergen-Belsen concentration camp. In 1946, he moved with his wife, Maeve, and their two sons, Sebastian and Fabian, to the Isle of Sark, where a daughter, Clare, was born. He continued writing and painting, producing (among other works) illustrated editions of R.L. Stevenson's classics: *Treasure Island*, *Dr Jekyll and Mr Hyde*, as well as Lewis Carroll's two *Alice* books and the fantastical *Hunting of the Snark*. In 1950, the success of *Gormenghast*, the second book of the trilogy, at last brought him recognition as a key figure in English literature. The last book of the trilogy, *Titus Alone*, was published during his final illness, as the progress of Parkinson's Disease led to his death in 1968. Since his death, screen adaptations of his stories and new editions of his works have only increased his renown as one of the most brilliantly imaginative authors and artists of our time.

Born in 1939 in London, Michael Moorcock left school at sixteen to become editor of *Tarzan Adventures*, a juvenile weekly, where he published his first works, inspired by Edgar R. Burroughs and Robert E. Howard. In 1961, he published the first tale featuring his most famous fantasy character, Elric of Melniboné. In 1964, already established as a groundbreaking author, he transformed the science-fiction magazine *New Worlds* into a highly regarded publication for New Wave fiction, publishing the most innovative writers of the day including J.G. Ballard, Thomas M. Disch, Thomas Pynchon and Samuel L. Delaney. Simultaneously, he was writing books of epic fantasy (*Corum*, *Hawkmoon*) and literary fiction. His controversial *Behold the Man* (1967) drew praise and death threats. Refusing to subscribe to a single genre, he wrote *Mother London* (1978) as well as the experimental Cornelius quartet, a series of grand scope and ambition. His tetralogy *Between the Wars*, which examined global causes of the Holocaust, is one of his masterpieces. His cosmology of the Multiverse is ambitiously conceived, portraying a group of dimensions and alternate universes that are tentacular, interconnected, perpetually shifting, and impossible to map. He has published about a hundred books, including novels, short story collections, anthologies, essays and comics. Like Peake he was recently included in the London *Times*'s fifty best British authors since 1945.